PART ONE

YOU CAN PAINT
PORTRAITS

NORTH LIGHT

Cincinnati, Ohio

CONTENTS

HOW TO USE THIS BOOK

Here are step-by-step demonstrations of a range of subjects in different media, designed specially to show you how to paint and draw portraits. To get the most out of these exercises, study each one first and then either re-draw or re-paint it yourself or, using the same medium, apply the same techniques to your own subject.

Copying. Don't be concerned about the fact that you are copying these exercises — many famous artists have used other artists' ideas and painting techniques to develop their own unique style. And copying the exercises will make learning the techniques easier for you as you won't have to worry about finding a subject, composition or design.

Stay loose. It is best to attack each project vigorously, and aim to make a strong painting. Don't worry about making mistakes along the way — the more you practise and experiment, the quicker and more dramatic will be your improvement in painting.

Experiment. By working boldly and taking risks with lines, colour, shapes and values, you will avoid the risk of your pictures looking tight and overworked. When you are making broad, generous strokes, don't hold your pencil or brush too near the point or your lines and brushwork will look tentative. Only when working on detail should you hold your brush or pencil close to the point — and keep your details to minimum when beginning a drawing or painting. Usually they are best left for the finishing touches.

Keep it simple. Select simple poses compositions to start with. Restrict yourself to a simple range of colours, and keep these crisp and pure by taking care not to overwork or smudge them on the canvas or paper.

If you observe these basic points, you will quickly produce surprisingly good paintings and then you can really start to experiment with bolder composition, more vibrant or subtle colour schemes, and develop your unique painting style.

Happy painting!

A QUINTET BOOK

First published in North America by
North Light, an imprint of Writer's Digest Bo
9933 Alliance Road
Cincinnati, Ohio 45242

Copyright © 1985 Quintet Publishing Limite
All rights reserved. No part of this publicati
may be reproduced, stored in a retrieval syst
or transmitted, in any form or by any mear
electronic, mechanical, photocopying, recorc
or otherwise, without the permission of th
copyright holder.

ISBN 0 89134 136 6

This book was designed and produced by
Quintet Publishing Limited
6 Blundell Street, London N7

Typeset in Great Britain by
Facsimile Graphics Limited, Essex
Colour origination in Hong Kong
Printed in Hong Kong by Leefung-Asco
Printers Limited

SELECTING A PALETTE

Painters in former times were necessarily obliged to work with fewer colours than present-day artists, for the simple reason that the full range had not then been discovered. Today we face the opposite problem of too much choice, and the array of colours can often be confusing and disconcerting. One answer is to work within deliberately self-imposed limits. This should not be thought of as curtailing artistic potential. On the contrary, it is a step which ultimately extends creativity, and one which is especially useful to the portrait painter. Flesh tones are extremely subtle, but vary so much, not just from subject to subject, but also within one small area of the same face, that most experienced painters stick to a personal formula often developed from an extremely narrow range of colours.

The colours you use are a matter of personal choice. The palette illustrated here is a suggested limited range which you might like to start with rather than a rigid restriction which must be strictly adhered to. The colours are titanium white, yellow ochre, cadmium red, Payne's grey, raw umber, ultramarine blue, and alizarin crimson **(below)**.

A more general choice of colours — again, a suggestion not a rule — would be titanium white, yellow ochre, cadmium yellow, light red, cadmium red, raw umber, black, ultramarine blue and alizarin crimson **(right)**.

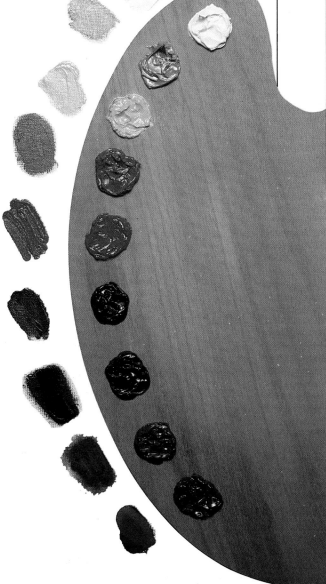

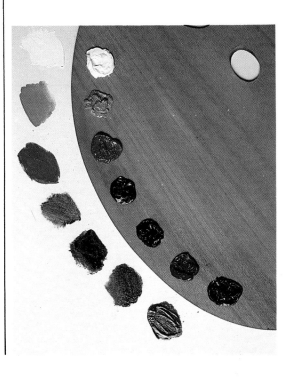

STRUCTURE OF THE HEAD AND FACE

The skull determines the basic shape of a person's head, but it is the muscles and movement of the head and face which give life to that head, and which makes one person different from another. These muscles, which are used to make facial expressions, are found under the skin of the face, scalp and neck. They are directly related to the features of the face and, while it is not necessary to remember the latin names which identify these muscles, it is extremely useful to understand where they are to know what they do.

Muscle movements are responsible for the way the lips move. The muscle surrounding the mouth, the orbicularis oris, is made up of a number of muscles which enter the lips from above and below. Other muscles pass into the mouth horizontally, while the buccinator muscle passes from the side of the mouth to the cheek. Each eye cavity is surrounded by the orbicularis oculi muscle, which allows each eyelid to close tightly or gently. Knowledge of these basic facial muscles helps artists to describe individual characteristics in detail.

When painting or drawing the head it is important to think how the neck is attached to the head, and how the movement of the neck affects the position of the head. The most important muscle in the neck passes from behind the ear to the inside of the clavicle. It is called the sternocleidomastoid. This muscle allows the head and neck to bend forward, the head to turn from one side to another, and the chin to tilt upwards. Although it is always tempting to start a drawing of the head with the lips or the eyes, it is wise to bear in mind the main structural parts of the cranium and face.

These diagrams describe how the bones and muscles work together underneath the skin. The frontalis muscle is the main reason for the eyebrows to move up and down; the mouth can move sideways as well as up and down because of the buccinator and muscles of the orbicularis oris.

temporalis

levator anguli oris

sternocleidomastoid

depressor anguli oris

platysma

clavicular attachment of sternocleidomastoid

frontalis

orbicularis oculi

orbicularis oris

masseter

buccinator

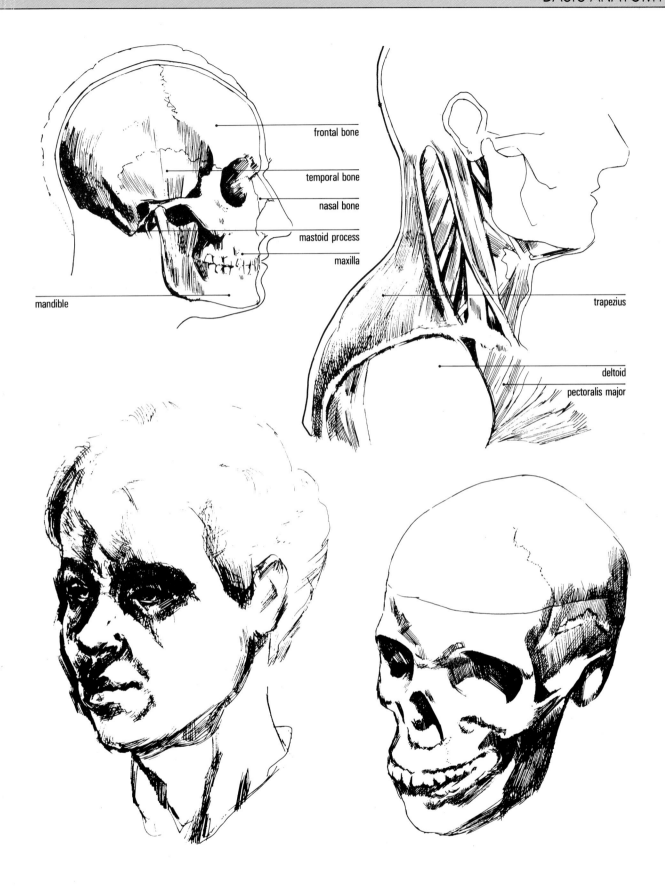

frontal bone

temporal bone

nasal bone

mastoid process

maxilla

mandible

trapezius

deltoid

pectoralis major

Flesh sits over the bone of the cranium, and transforms the macabre skull into familiar features. The repeated angle of the head and skull illustrates how the shape of the nose and the thickness of the flesh are the main reasons for the shape of the face being different from the structure underneath. It can also be seen how the muscles affect the way flesh moves.

THE IMPORTANCE OF LIGHT

Light and shade are the portrait painter's most valuable tools when painting the human face. The complex anatomy of the head and face — the bone and muscles, and the skin which covers them — are only seen by means of a constant source of light.

The photographs on this page show the

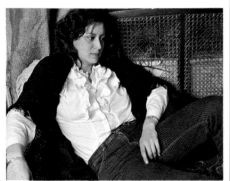

same model posing in different lighting conditions, and demonstrate how these not only affect how we perceive the structure and features of the face, but also it affects the colours and tones. Traditionally artists have depicted the light source as above, and slightly to one side of the sitter. This is because it was realized that a painting looked more natural if the light source imitated the position of the sun. Leonardo da Vinci held this view and in nearly all his portraits the light source is made to look like sunlight. He used this constant light source to help indicate the changes in direction of the planes on the forms. Painters after Leonardo adopted the same device, and it became common practice to indicate the shadows of the nose and brow to explain the volume and shape of the head. In a similar way the chin would cast a shadow across the neck, and the cheekbone

furthest from the source of light would be bathed in shadow.

Leonardo's advice about lighting was connected with his realization that the emotional content of the picture would be, to some extent, the result of it. If the lighting were directed from below the face, the effect would be quite different — some artists have used this quality to their advantage, creating unusual theatrical or dream-like effects which automatically

distance the spectator.

Edgar Degas was fascinated by the effect of artificial lighting and sometimes transferred the elements of theatricality into a portrait set in a domestic interior. He realized that by not revealing the source of light he could take more liberties with its effects.

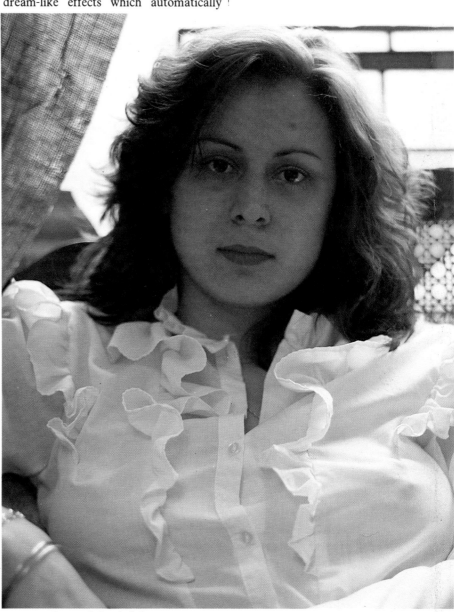

A normal electric light, placed slightly above the model brings out the features and form of the face without being too harsh. The side furthest away from the light source is thrown into soft shadow which helps to define the contours of the head (**top left**). *An angled lamp, placed on one side throws the far side of the face into deep shadow, making it difficult to see the shape of the head* (**above left**)

Soft studio lighting, with reflectors placed at each side of the model produces a pleasing photograph but most artists would find the effect too flattening to produce an interesting painting (**above**).

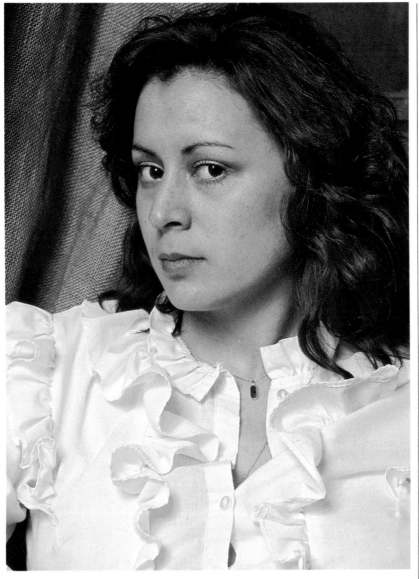

Natural light from a skylight produces soft contours and shadows **(left)**. *However, natural light changes constantly, and many artists find it necessary to make colour sketches or take a photograph, enabling them to continue work after the light has changed or dimmed.*

Strong artificial lighting directed from one side produces shadows with hard edges which dominate the face. A white cloth can be hung on the opposite side to act as a reflector which will slightly soften the effect, throwing a soft light back onto the shaded side of the face **(top)**. *Without such a device the result can be ghoulish and unattractive* **(above)**.

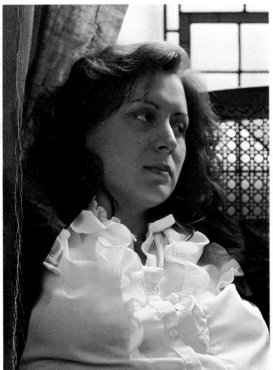

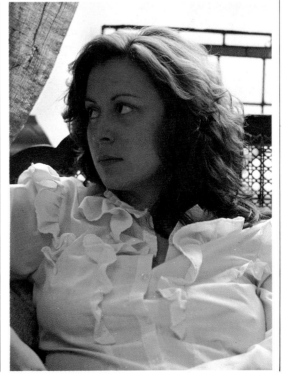

Turned towards the window, the form of the face and features is clearly defined by the daylight **(far left)**. *When the model turns her face the other way, the features are lost and the face flattened into a dim shadowy shape* **(left)**.

This painting was completed in 1905, a crucial year in the development of the Fauve style. It was at the Autumn Salon that the title 'Fauve' was coined. During that summer Matisse (1869-1954) and Derain (1880-1954) worked together in the south of France at Collioure. The Fauve style is usually defined in terms of liberated bright colour; it was a short-lived style, concentrated in the years 1903 to 1907 and was the product of friendships and artistic contacts. Its artists had very different styles of painting but they held a common concern for using bright, non-descriptive colour.

This partnership between Derain and Matisse is celebrated in a pair of portraits from 1905, portraits which also highlighted the differences between the styles and aims of the two artists. In his study of Matisse,

PORTRAIT OF MATISSE
by
ANDRE DERAIN

Derain's brushwork shows his debt to Van Gogh, whom he greatly admired. Derain's touch is reminiscent of Van Gogh's parallel hatched brushstrokes, particularly in the handling of Matisse's beard. In his colour, however, Derain's allegiance is to Gauguin, whose work he had seen that summer. The burnt golds, sharp greens and brick reds of Gauguin's later Tahitian paintings are the basis for Derain's palette

in his portrait of Matisse. With the exception of the cobalt blue and white of the shirt, all his colours are mixtures, achieved by combining two or more hues. The result is a muted harmony which is comparable to that found in Gauguin's pictures. Within the broad areas of colour, Derain's hues are varied and modified, but overall the picture appears as a series of blocks of flattish colour.

By 1907 Derain had begun to abandon the brilliant colours of Fauvism, and, later under the influence of Cubism he returned to a sombre tonal palette, dominated by earth colours. The poet Guillaume Appollinaire (1880-1918) described the Fauve period of Derain's style as 'youthful truculence', stressing the sobriety of his post-Fauve work and his passionate study of the old masters.

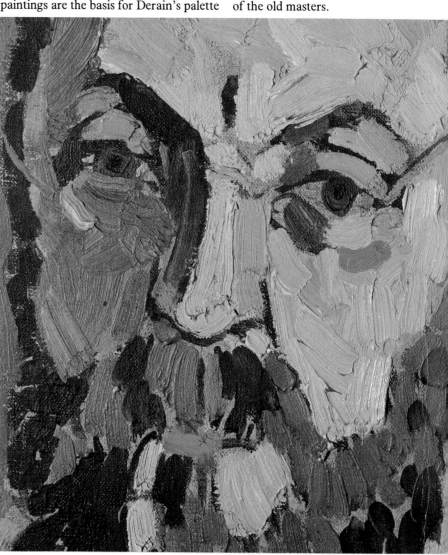

Top. *The features of the face are reduced to simplified blocks of colour and tone. Broad single strokes are used for the eyelids, brow and nose. The spectacles are merely suggested by an orange stroke or two, and the*

spectator is left to complete the image.
Above left. *A single sweep of red provides the pipe stem. The bowl is worked in bright, probably chrome, yellow. The pale blues of the shirt are applied in strokes which follow the*

outline of the shape of the pipe. The coffee colour of the ground shows through the blocked in colours.
Above. *The layers of colour are almost entirely applied opaquely, usually with the addition of white to give a subtle luminosity.*
Although the brushwork has a lively, almost separate existence in places — the

Thinly diluted paint was used for the outlines, which was immediately blocked in with no additional underpainting, in thickly loaded brushstrokes.

beard is a good example of this — in general it is largely descriptive, following and sculpting the forms of the face. A mixture mainly of viridian green and white, describes the shadows applied over wet to modify a bluer tint below

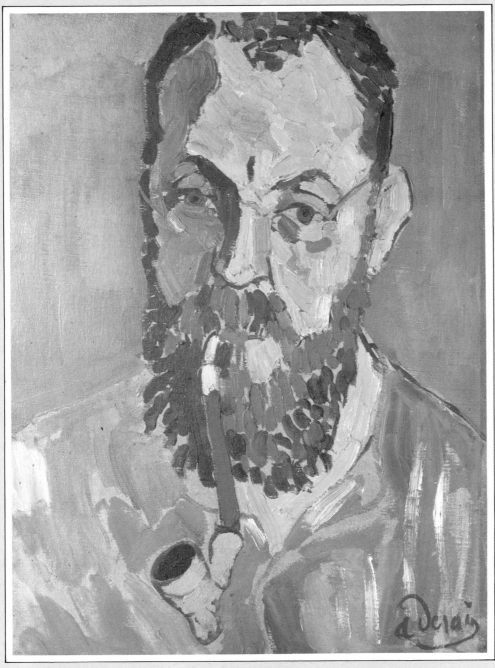

Derain and Matisse worked together at Collioure in the summer of 1905, when this painting and Matisse's portrait of Derain were both painted. Matisse appears intensely introspective in this dynamic study — his gaze is directed outwards but not focussed upon the spectator. The angle of his head, pitched slightly forward and high on the canvas, emphasizes this mood. A lively fall of strong light and shade accentuates the form of the head. The lights are handled in warm orange pinks, the darks in cool greens. The painting is handled directly and spontaneously, rapidly executed in large, loaded brushstrokes, with the coffee-coloured background showing through between the broken colours which dominate the painting. The elongated form of Matisse's head and beard relate well to the standard format, vertical canvas chosen by Derain.

HATS IN PORTRAITURE

The clothes we wear are important to us, not just as a protection against the elements, but also because they express our personality and often our status. Official portraits usually portray the subject in a uniform, or in ceremonial clothes — the Chancellor of a university for example, will be shown wearing his robes of office.

Hats are particularly important to the portrait artist because they can be used to emphasize the personality of the subject. Just think of a young child's straw bonnet and contrast it with the worn and battered headpiece of an elderly person who has worked in the fields, exposed to the elements all his or her life.

The shape of the head and features can be shown to advantage when their contours are thrown into sharp relief by the shadow cast from a brimmed hat.

In the drawing on the left, the hat throws the subject's face into almost total shade, giving an impression of intense heat and strong sunlight. The hat also plays an important role in the composition of this drawing. A strong, horizontal shape across the top of the paper, the dark hat picks up the tone of the dress, and this dark tone acts as a 'frame' to the head and shoulders.

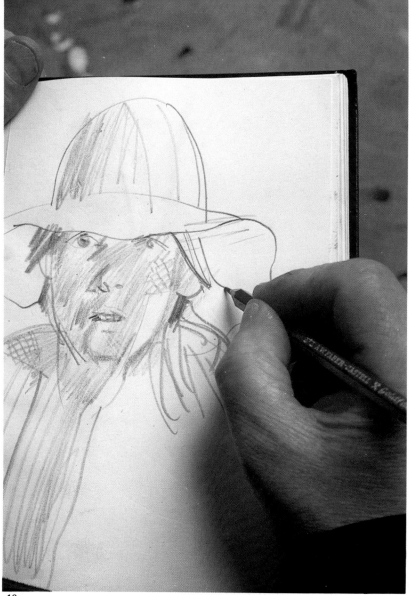

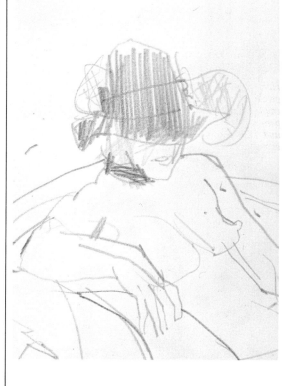

*These drawings (**above and left**) show how a hat can actually create a personality. The subject on the left looks quaint and old fashioned because of the shape of the hat she is wearing; the second drawing shows a rather provocative and mysterious nude, with her hat pulled enigmatically down over her face.*

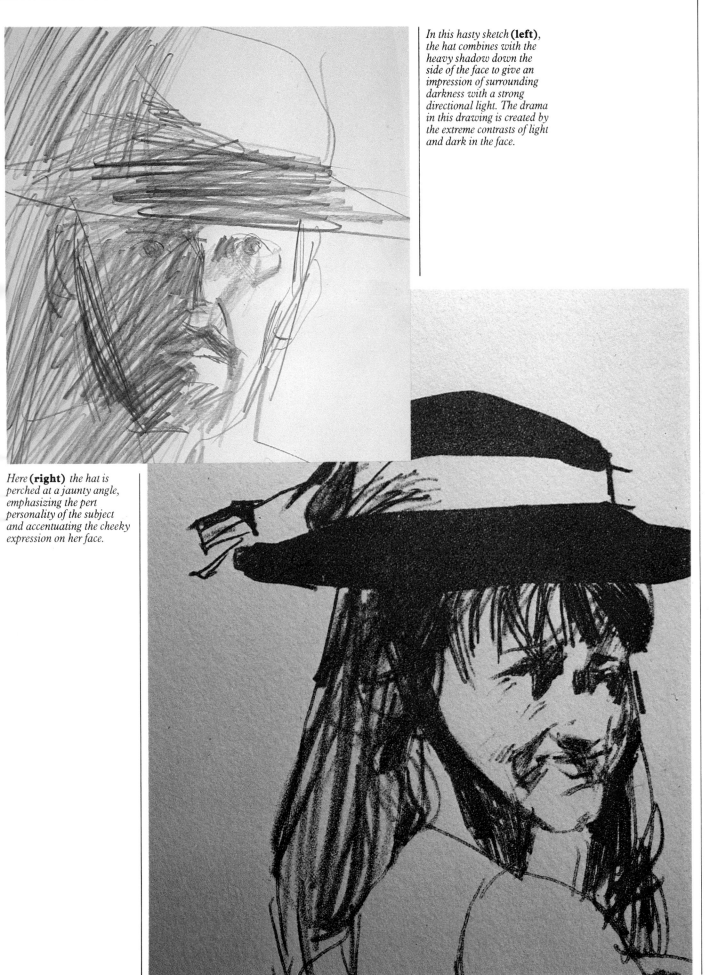

In this hasty sketch **(left)**, the hat combines with the heavy shadow down the side of the face to give an impression of surrounding darkness with a strong directional light. The drama in this drawing is created by the extreme contrasts of light and dark in the face.

Here **(right)** the hat is perched at a jaunty angle, emphasizing the pert personality of the subject and accentuating the cheeky expression on her face.

PATRICIA

Pastels are an especially sensitive medium to use for figure and portrait work — with their velvety bloom and softness they suit the delicate textures and tone of flesh. The delight of pastels lies in the way in which you can lay layers of almost transparent colour to build up skin tones, yet can also use the medium boldly and opaquely to block in areas of strong, bright colour.

Working with pastel requires a combination of drawing and painting skills — it can be treated either as a linear medium using outlines and loosely hatched textures, or it can be used like paint with the colour laid in broad, grainy patches and blended with a finger or a rag.

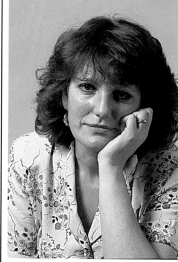

Find a comfortable position for your subject — one which looks natural and which includes enough of the shoulders and clothing to make an integrated picture (far left). Work on a light or medium tinted paper in order to get the full effect of tonal range of your pastel set — both light and dark colours can be used on a medium coloured ground. Start by laying in the light areas (left), looking carefully at the skin tones and trying to differentiate between the warm and cool colours.

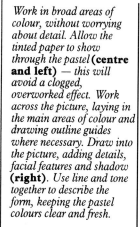

Work in broad areas of colour, without worrying about detail. Allow the tinted paper to show through the pastel (centre and left) — this will avoid a clogged, overworked effect. Work across the picture, laying in the main areas of colour and drawing outline guides where necessary. Draw into the picture, adding details, facial features and shadow (right). Use line and tone together to describe the form, keeping the pastel colours clear and fresh.

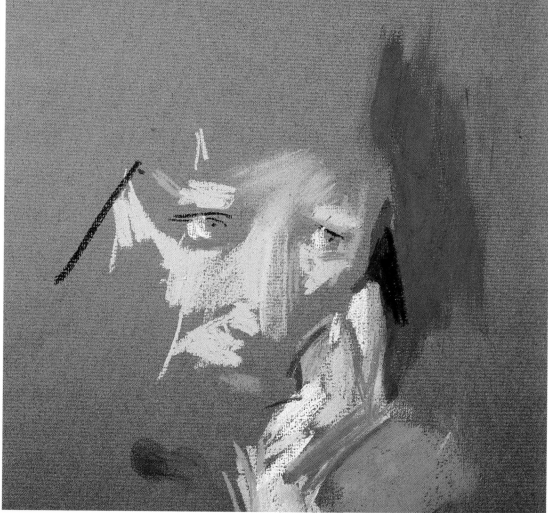

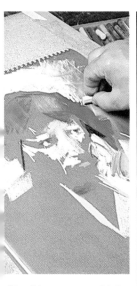

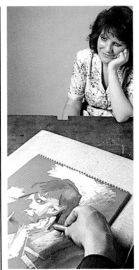

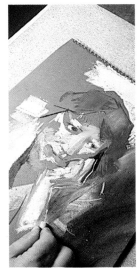

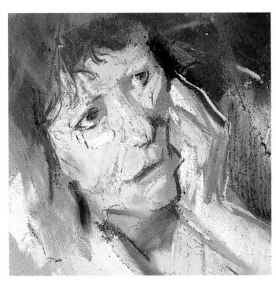

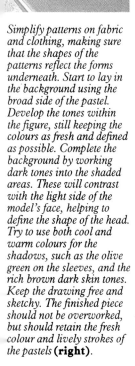

Simplify patterns on fabric and clothing, making sure that the shapes of the patterns reflect the forms underneath. Start to lay in the background using the broad side of the pastel. Develop the tones within the figure, still keeping the colours as fresh and defined as possible. Complete the background by working dark tones into the shaded areas. These will contrast with the light side of the model's face, helping to define the shape of the head. Try to use both cool and warm colours for the shadows, such as the olive green on the sleeves, and the rich brown dark skin tones. Keep the drawing free and sketchy. The finished piece should not be overworked, but should retain the fresh colour and lively strokes of the pastels **(right)**.

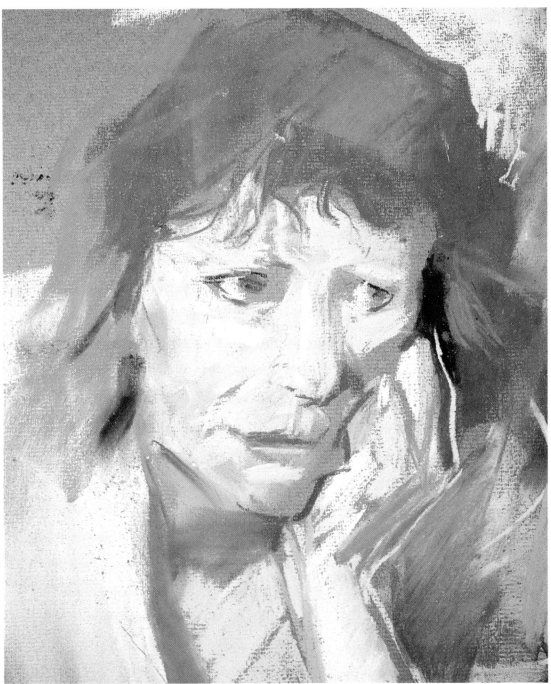

MALE PORTRAIT

In the male face the lines tend to be harder and more acute than those of most females, and these elements will often dictate the feel of the finished drawing. This particular pose has a strong directional light from one side which emphasizes the deep recesses below the lower lip and above the chin.

A quick informal portrait is easier if the artist is familiar with the chosen medium and techniques. And regardless of the superficial features of the subject the artist should be aware of the underlying structure of the bones, muscles, tendons and cartilage — the building blocks upon which all figure work and portraiture are based. This is most true when the artist is trying to do a quick sketch, where the goal is to capture the essential and outstanding

features of the model as quickly as possible. A more laboured and detailed drawing would allow you to correct and change the drawing, but a quick sketch requires the artist to make marks accurately with no revisions.

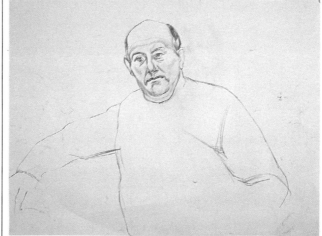

When drawing portraits it is important to understand the relationship of the skull to the head — and this differs according to the age of the subject . Use a 2B pencil to pick out the shape of the head and features **(top)**. *Work into this, noting the skin texture and surface wrinkles* **(left)**. *Use these characteristics to help develop the face and expression, paying special attention to the lines around the eyes and mouth* **(below)**.

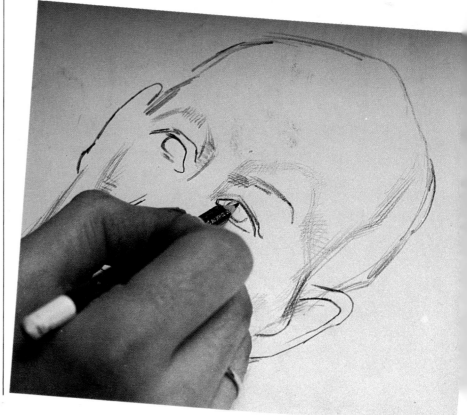

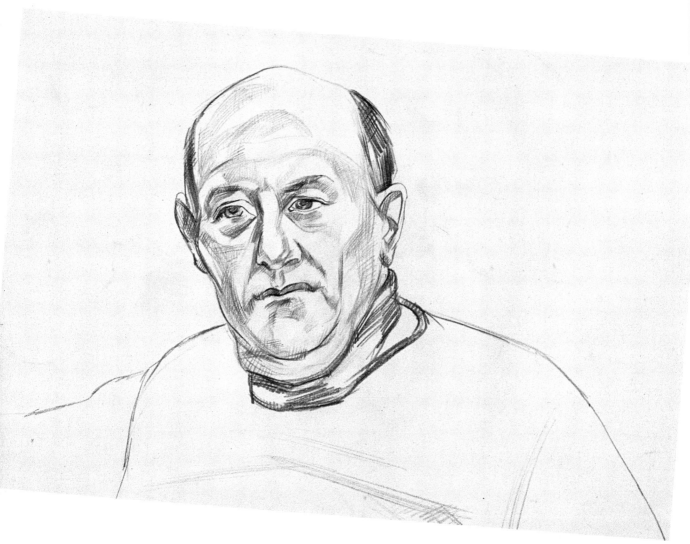

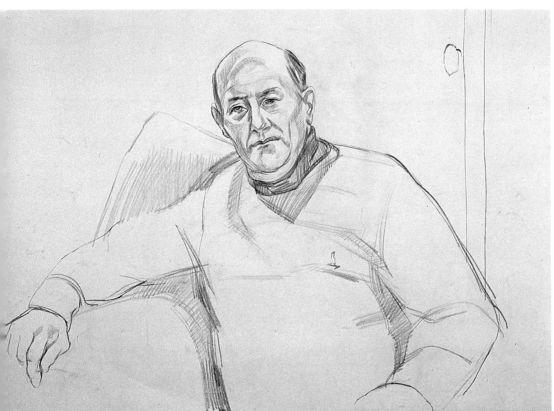

Work into the whole face, defining the features and hairline, and intensifying the tones **(above)**. *Add the finishing touches by drawing in patches of dark tone to show folds and details in the clothing* **(left)**.

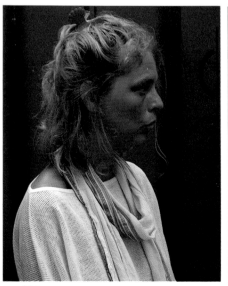

ANNIE

Perhaps the most important criterion of a good portrait is how well it captures the likeness of the sitter, but that is far from being the only requirement. The portrait should also capture something over and above the mere physical attributes, giving some impression of the personality and character of the person you are painting. In some cases this may present the artist with the problem of reconciling his or her view of the subject with the subject's own idea of a good likeness!

Try to persuade members of your family to act as models — you already know them very well indeed and can concentrate on the technicalities of getting a likeness.

Think carefully about the best way to light your sitter, the general composition of your painting, whether fairly traditional or relying for impact on an unusual juxtaposition of shapes, and whether or not you are going to include any extraneous objects or background details to give added interest. In this painting much of the result depends on the strongly silhouetted profile.

If you are not familiar with watercolour, it would be wise to practise controlling the paint before embarking on this project. Remember, watercolour is transparent, so you cannot paint light colour over dark — you must work from light to dark, allowing the paint to dry between each stage.

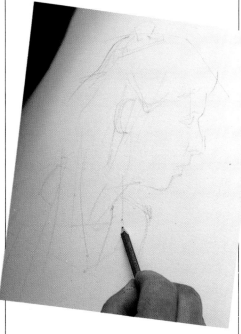

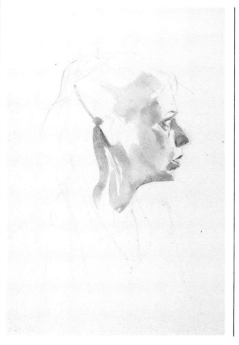

*Take a profile view of the model (**top left**) and draw a light pencil outline onto stretched watercolour paper (**centre left**). Lay in the basic structural tones around the nose with a mixture of burnt umber, cadmium red and ultramarine blue (**above**). Wet the paper before applying colour. Define the cool areas of the nose and eyes with a cooler skin tone, mixed from burnt sienna and ultramarine blue (**far left**). Treat the hair area with a pale yellow ochre wash, adding cool shadows of burnt sienna and ultramarine blue when the yellow is dry (**left**).*

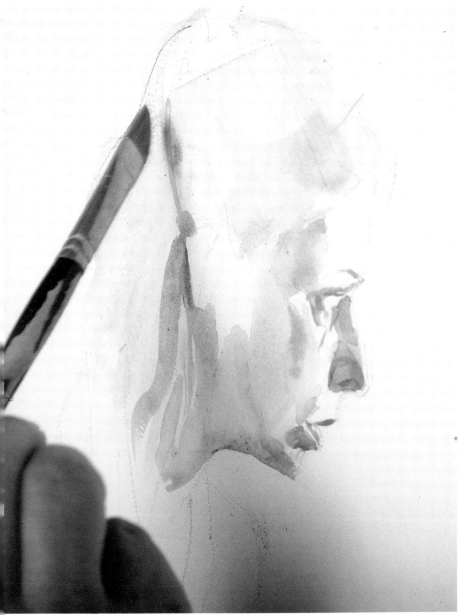

Continue to work into the hair with yellow ochre and shadow colour to create depth, leaving highlight areas pale **(above, left and right)**. *Add dark shadow areas to the neck* **(bottom left)**, *defining the outline of the hair* **(bottom right)**.

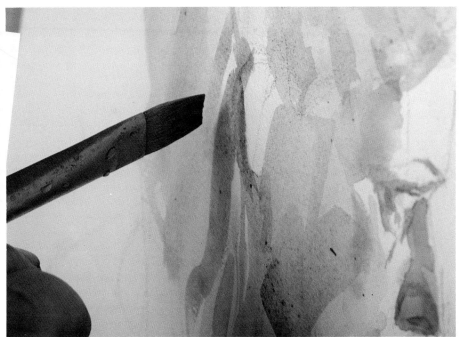

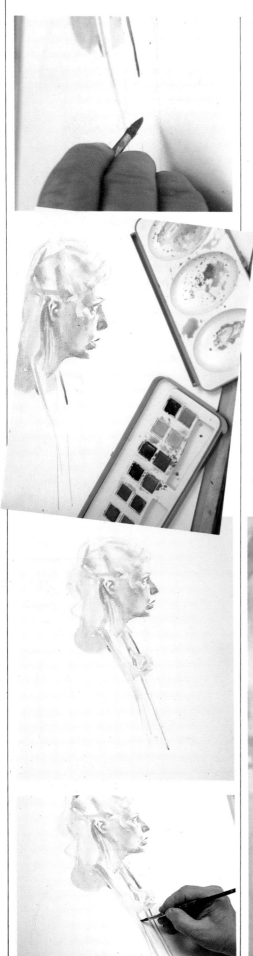

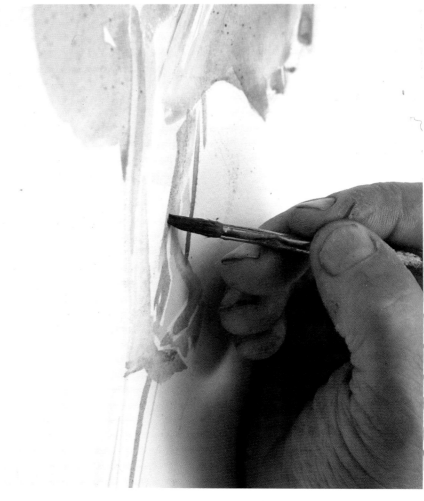

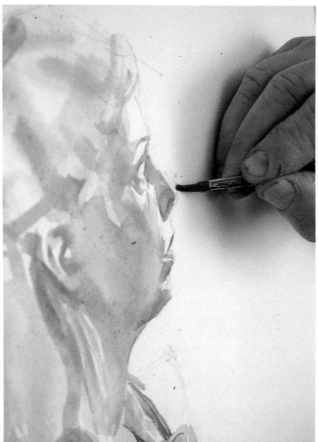

Start to lay in the clothing by indicating the fold and contours in linear strokes **(top left)**. *Introduce new, clearer colours to your palette to do this* **(above left)**. *Work into the shadows and folds* **(above)**, *taking care to maintain a tonal balance with the face and head* **(far left)**. *Add enough detail to depict the character of the clothing* **(bottom left)**, *without overworking this area. Prepare to add the background colour by first wetting the area around the face and figure* **(left)**.

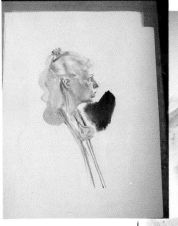

Mix enough background colour to cover the required area, and start to apply it as flatly as possible **(above)**. Work carefully up to the contours of the face, leaving tiny edges of white paper to depict highlights **(right)**.

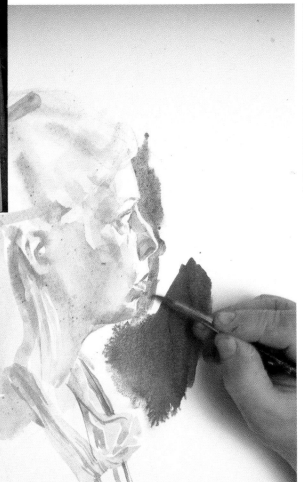

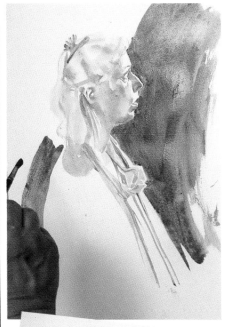

Working quickly to avoid patchy colour, continue to lay in the background around the figure **(top)**. Paint accurately, but use flowing strokes round the hairline to preserve the shape and character of the hair **(above)**.

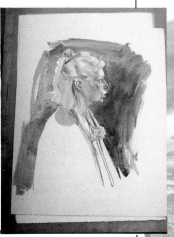

Strengthen tones and colour within the face and figure **(right)**, bringing the image into line with the newly established background tone **(above)**.

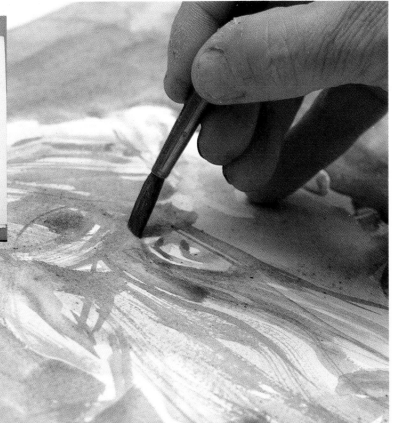

19

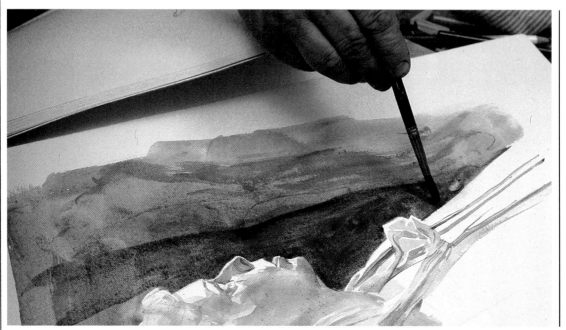

To capture the light falling
on the face, darken the
background on the relevant
side of the picture (**left**).
Use the background colour
to redraw any indistinct
outlines and clarify the
image (**centre left**).
Where necessary, make any
alterations and additions to
the skin tones, echoing the
background colour in the
flesh areas (**bottom left**).
Take care not to flatten the
face, and to maintain the
tonal contrast between the
shadow and white
highlights. The finished
painting (**opposite**)
reflects the subtle use of
wash and colour and the
suitability of water colour,
when carefully used, to
portrait painting.

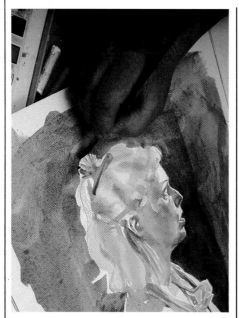

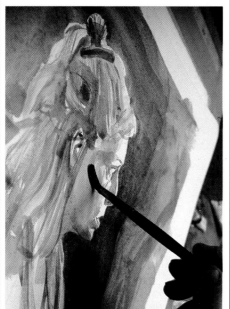

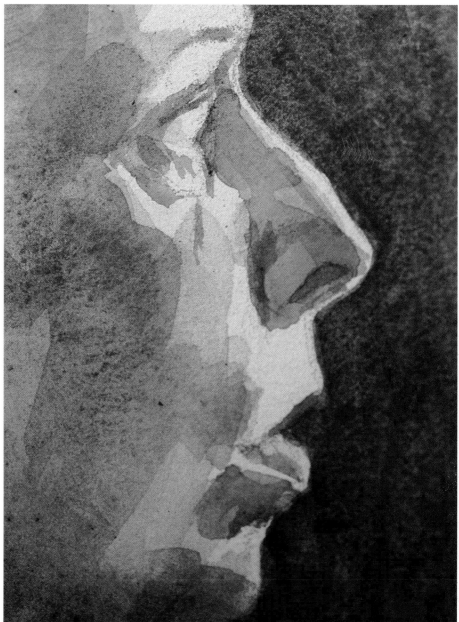

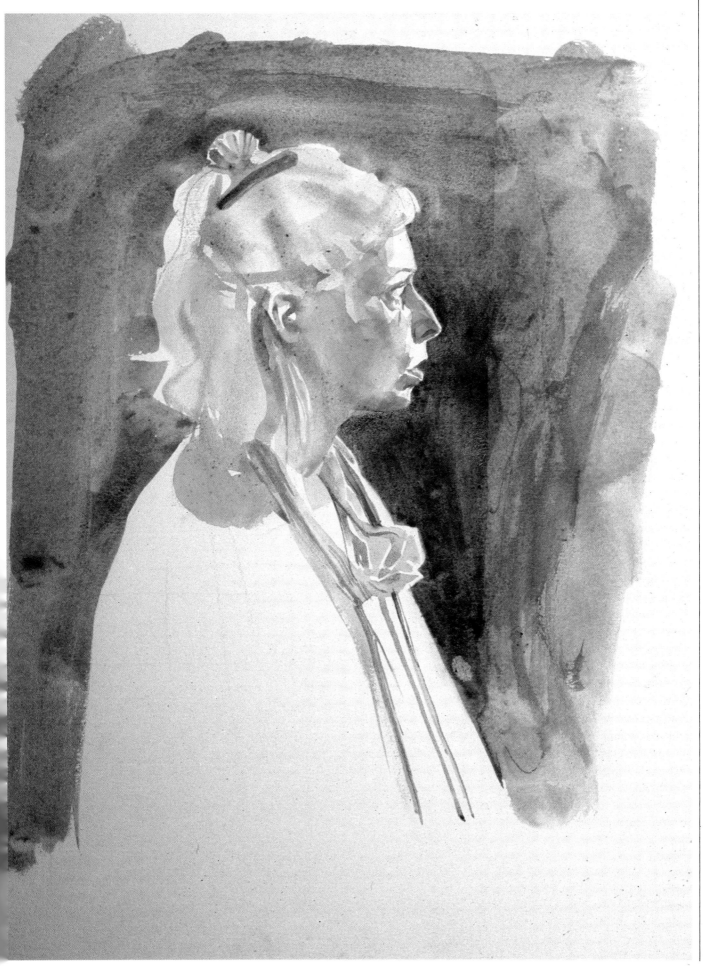

GIRL IN BLUE and BOY IN OVERALLS

A water colour sketch may result in an interesting finished picture, or may be used as a reference for a larger work. In the first picture, the Girl in Blue, the effect is sketchy and shows a lively impression of the general form of the face and figure, lightly modelled with colour and tone. The second portrait, Boy in Overalls, is a tighter, more finished painting in which the artist has taken time to add final details.

The essence of the technique of the first picture is to lay the colour in watery pools which give the surface a loose, rippling texture. Generally the paint is allowed to dry before each new colour is applied in order to get the full effect of the overlaid colour and liquid shapes. However, many of the initial face and hair tones were laid while the underlying colour was still damp. This technique, known as painting 'wet into wet' allows the two colours to merge slightly, producing a soft, blended edge where colours meet. This painting is quite small — about 12in × 16in (30cm × 40cm) — so you will only need two sable brushes for the entire picture. Use a No 7 for the washes, and a No 3 for small areas and linear features. The artist worked on stretched cartridge paper with a palette of black, burnt sienna, burnt umber, cobalt blue, gamboge yellow, scarlet lake and ultramarine blue.

The second picture is larger, measuring 16in × 23in (40cm × 57.5cm). Here the artist chose a palette of burnt umber, burnt sienna, cadmium red, cadmium yellow, chrome green, ultramarine blue and yellow ochre. The considerable detail and fine colour was applied with sable brushes, Nos 00, 1 and 2.

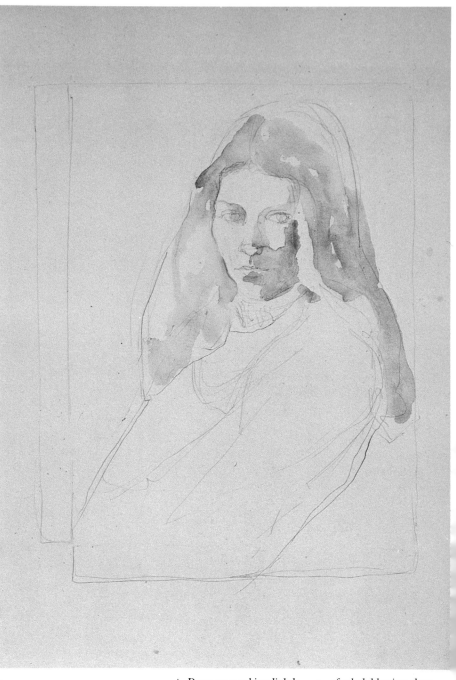

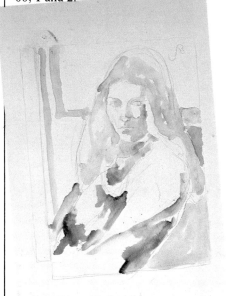

Draw your subject lightly with a pencil. The lines should be free and unrestricted to act as a guide to the colour. The drawing should not be stiff and rigid, otherwise you will be inhibited as you apply the colour and your work will be too tight from the outset. Work over the hair and face with wet pools of colour — scarlet, yellow and burnt umber — allowing the tones to blend in places (above). Wet the paper in the shadow areas of the blue sweater, and drop touches of cobalt blue into these areas — the colour will run taking the shape of the watery patches. Block in thin patches of colour to suggest the background (left). This will be developed later, but at this stage it is necessary to break up the flat space around the subject to avoid automatically relating the tones of the figure to the bright white tone of the paper — a tone which will be changed in any case as work progresses.

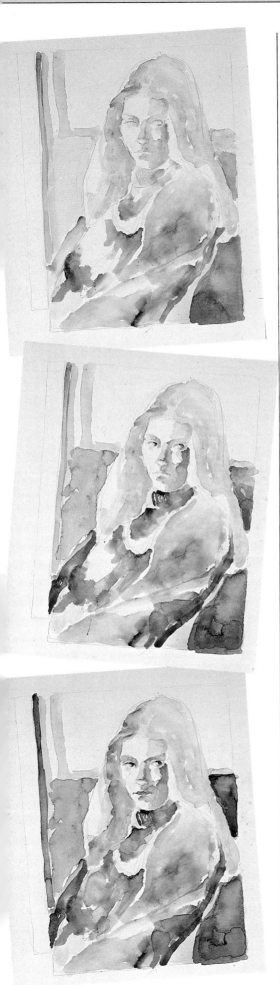

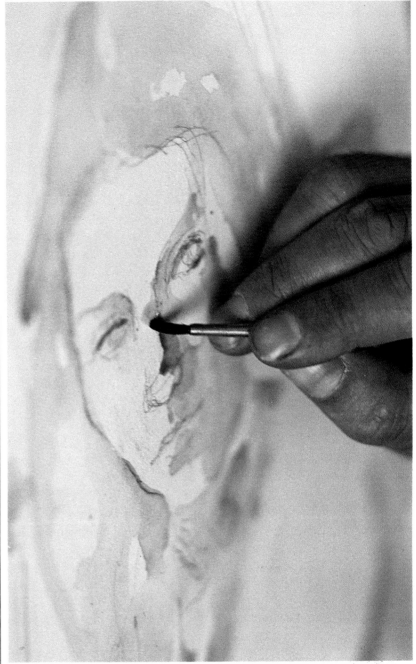

Left top to bottom.
Strengthen the colour over the whole image, developing the structure of the forms. Keep the paint fluid and allow the colours to merge on the surface (**top left**). *In this way the gently rounded planes of the face, fabric and hair will emerge as natural forms. Model the face with heavy patches of red and brown — mix the brown from scarlet, raw umber and burnt sienna* (**above**) *— drawing in the detail around the eyes with the point of the brush. Extend the background colour, using a mixture of ultramarine and burnt umber to darken the shadows. Redefine the shapes in eyes and mouth. Lay in a black wash across the background to bring the shape of the head forward, strengthening the overall colours accordingly to relate to this.*

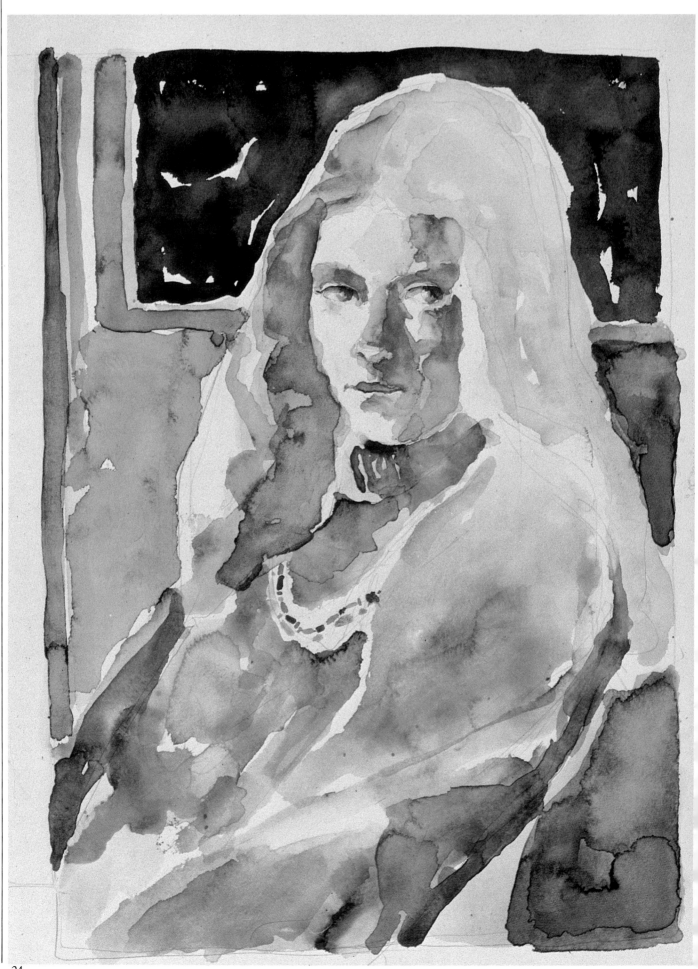

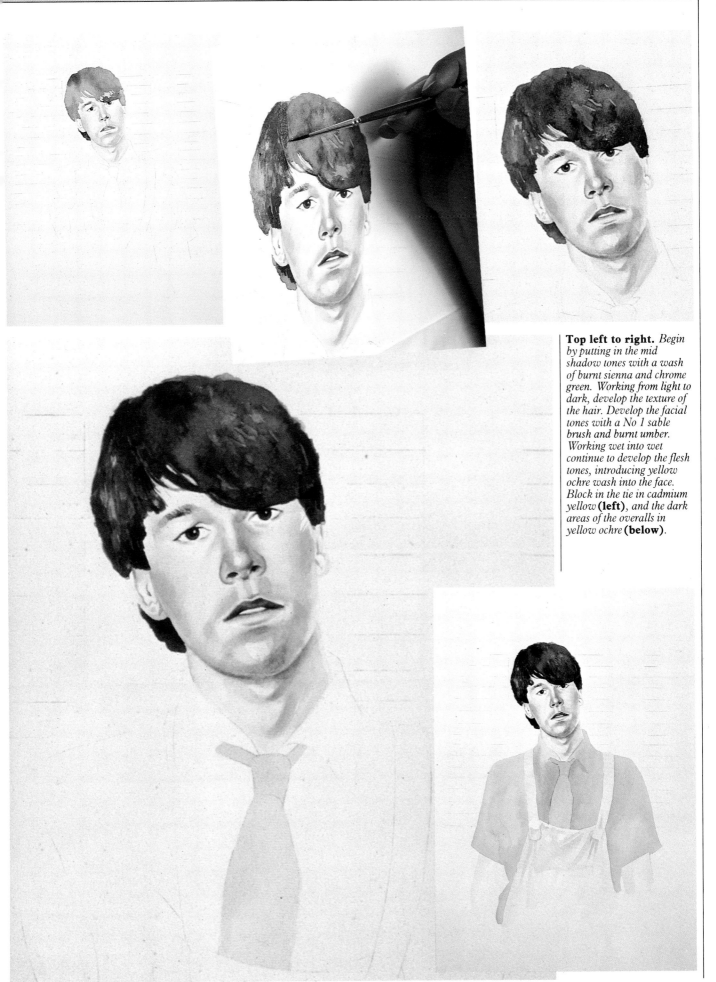

Top left to right. *Begin by putting in the mid shadow tones with a wash of burnt sienna and chrome green. Working from light to dark, develop the texture of the hair. Develop the facial tones with a No 1 sable brush and burnt umber. Working wet into wet continue to develop the flesh tones, introducing yellow ochre wash into the face. Block in the tie in cadmium yellow* (**left**), *and the dark areas of the overalls in yellow ochre* (**below**).

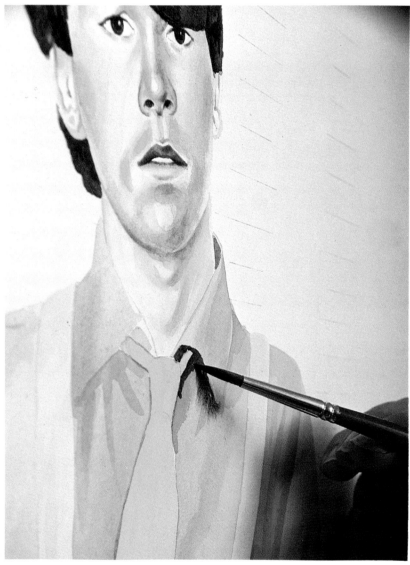

Using a strong blue and a small sable brush, add the shadow areas to the shirt. Notice how the paint bleeds naturally into the damp surface (left).

Darken the hair colour with burnt umber and a fine brush, using the strokes to suggest the direction and texture of the hair (right). When the paint is thoroughly dry, work back into the face and detail areas with a sharp coloured pencil. Here the artist uses light red to strengthen the shading on the side of the nose (far right). Finally strengthen the horizontal lines in the door with a grey pencil, and mix a light grey wash to accentuate the shadows on the door and to block in the boy's shadow.

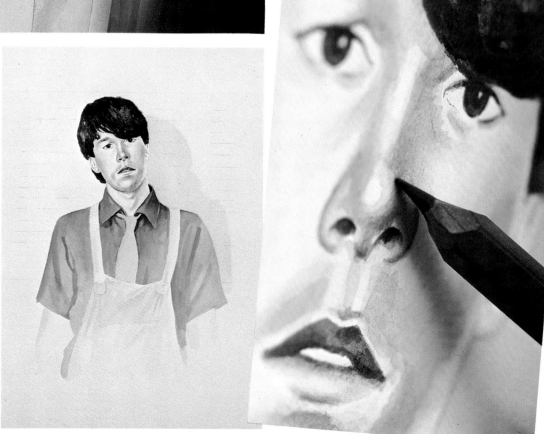

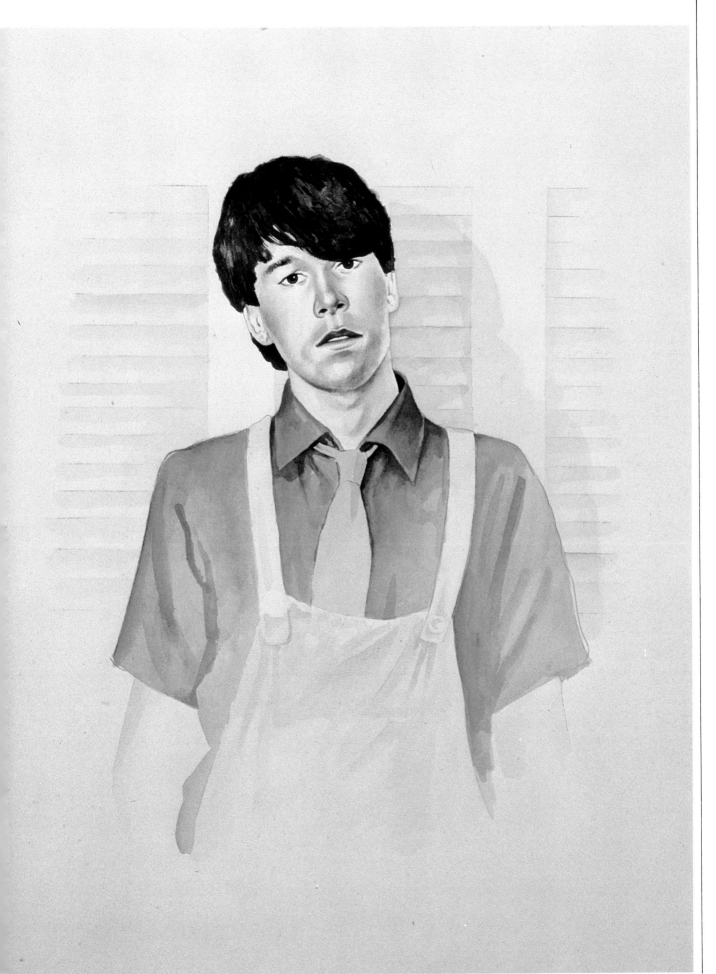

JANE IN TURBAN

The rapid-drying properties of acrylic paint enable the artist to alter a painting radically, changing colours and tones quickly and easily in a way which is not possible with any other medium. It is particularly suitable for portrait painting, because the elusive flesh tones — never satisfactorily rendered in opaque colour — can be built up quickly in layers of thin, translucent glazes. When using oils, the traditional glazing method is a lengthy process because the paint must be allowed to dry between layers. With acrylic, the thin colour dries almost instantly and can be painted over straight away.

Acrylic also enables corrections to be made easily. When used undiluted, or with very little water, the colour is opaque and has good covering, or hiding, ability. In the first stage of this painting, you can see the ghost of a figure underneath the drawing. This was the artist's first attempt, which was abandoned because the composition was unsatisfactory. Instead of rejecting the canvas altogether, the artist merely gave it a coat of acrylic paint which was dry enough to paint on within minutes.

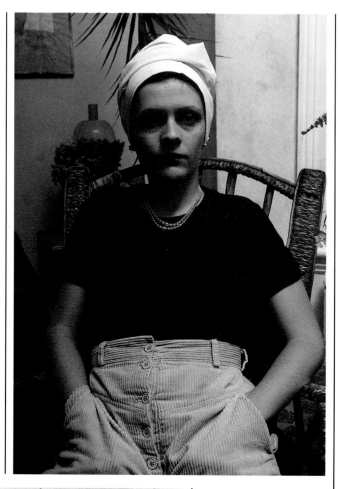

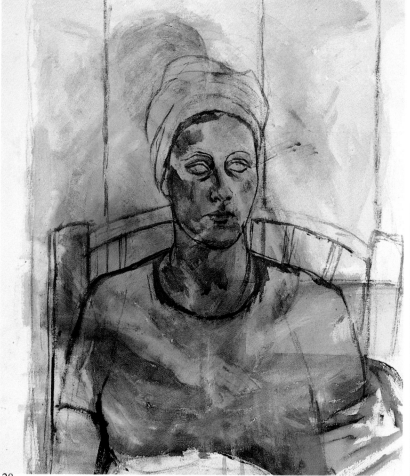

The pose is dramatic with a strong directional light coming from one side. Dark shadow envelops half of the composition, and the contrasting arrangement of light and shade is reflected in the clothes worn by the model, especially the white turban and simple black top **(above)**. *The artist was not satisfied with a previous attempt to paint the same pose and painted over the unsuccessful image with a coat of white acrylic paint. The resulting mottled canvas provides an ideal support for the second attempt, as the artist does not have to tone down the white ground, as would normally be the case. The underpainting is done directly onto the canvas in black* **(left)**.

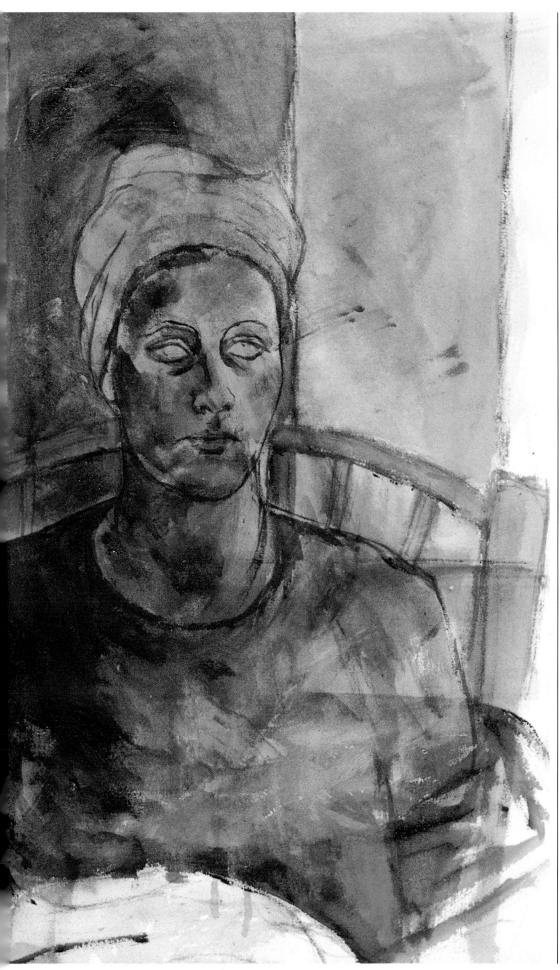

The drawing should be simple and precise — observe the proportions and contours of the subject carefully, drawing these accurately. If necessary keep changing the outline until you are satisfied with its precision — any weakness and inaccuracy at this stage will be reflected in the final picture. Your initial drawing will eventually be covered by opaque acrylic colour, so feel free to make corrections at this stage — they will not be visible in the finished picture. When the drawing stage is complete, start to block in the main areas of colour using extremely thin washes of colour **(left)**. In this painting, in which the first attempt is allowed to function as an underpainting, the dark bluish black used in the previous painting provides a foundation for the flesh tones which will follow.

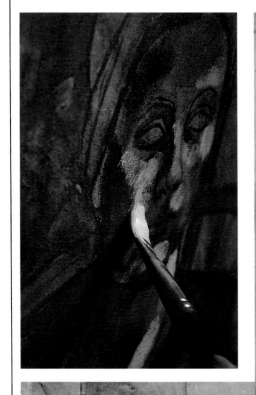

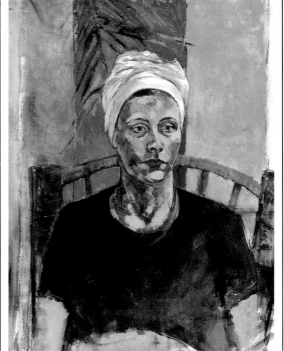

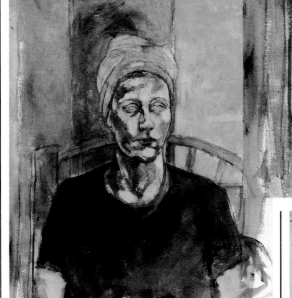

Apply the light flesh tones, using a predominantly white mix with added tints of red and yellow (top left). Because this paint is stiffer than the earlier fluid washes, the grain of the canvas picks up the paint as it is lightly dragged over the surface. Acrylic is not water soluble once it has dried and subsequent layers of paint will not disturb the colour beneath. Work into the

composition using pale colours to lighten the overall image. Restate the dark background areas with light washes of green and pink (above). Work into the face, defining the features and developing the planes of light and shade across the head. Gradually introduce colour and detail into the face, and develop the white tones of the turban (top right).

Each colour on the face is applied as a separate patch and no attempt should be made to blend the individual areas of colour together. Instead, build up the tiny planes of light and shade until the image read convincingly in the viewer eye. This makes the build of form a slow process, but each area of the face is gradually brought to the same degree of completion. Sketch in the rough outline of the background fern (left). As the painting nears it final form, add finishing touches — here (opposite) the artist add touches of white to the eye.

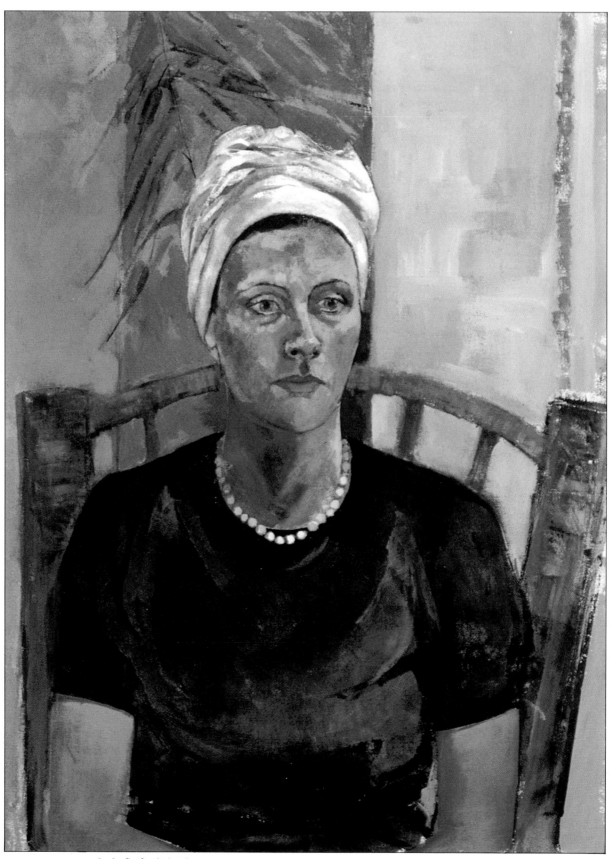

In the final painting the last-minute additions of the fern and necklace have served to provide points of focus around the head and alleviate the simpler compositional divisions of the picture. Although the figure is placed squarely on the canvas and fills the picture space, too rigid a symmetry is avoided by placing the fern off-centre at the top. The gentle arc of the chair back and its warm colour serve to complement the curve of the bare arms.

Similarly, the pearl necklace echoes in form and colour the white turban framing the face.

YOU CAN PAINT
PORTRAITS
IN OIL

MATERIALS

If you have not painted oils before you will need to buy some simple equipment. It will be cheaper to buy the items separately rather than as a ready-made set. You only need a few colours to start with — you can mix other colours from the basic palette. Start with titanium white, ivory black, cobalt blue, yellow ochre, viridian, raw umber and cadmium red. Other useful colours are French ultramarine, burnt sienna, alizarin crimson, terre verte (a translucent green earth colour which is useful for portraits) and cadmium yellow. There are two ranges of oil paint: Student's colours are the cheapest and are adequate for most purposes; Artist's colours are more expensive because the pigments are purer and there is a greater range of colours. You will need turpentine to dilute your paint, white spirit for cleaning your brushes and some linseed oil. Oil painting brushes are usually made from bleached hog's hair or red sable. Hog's hair are used for detailed work as they are usually smaller and thinner. Brushes are expensive and should be treated with care. Always clean them after use. Finally you will need a suitably prepared painting surface — hardboard primed with an acrylic primer is cheap and you can use the smooth or the textured side. Oil sketching paper and prepared boards can be bought from any art supply shop. Prepared canvases are expensive but you can buy canvas and stretchers and prepare own quite cheaply and simply.

INTRODUCTION

History of portraiture

The art of portraiture has passed in and out of favour throughout history. The Greeks produced some of the most beautiful representations of mankind ever, but the sculptors and painters of Ancient Greece were concerned with representing ideal rather than realistic images. The Greek passion for the ideal obliterated personality; a man who is truly perfect loses those characteristics which make him an individual. The Romans on the other hand produced portraits which were often unflattering and sometimes brutal in the realism with which the subjects were depicted. In A.D. 311 the Roman Emperor Constantine I proclaimed Christianity the official religion of his state — a decision which had a profound effect on the art of the Western world. Secular art was proscribed and only subjects with a religious message were allowed. Portraits of donors were sometimes included in paintings but generally the art of portraiture went into a decline until it was revived during the Renaissance when it achieved an importance it has held fairly consistently ever since.

Approaches to the portrait

Artists vary in their approach for some the presentation of the personality of their subjects is important — this has sometimes cost them their reputations and the support of wealthy patrons. Artists who can achieve good likenesses have usually been able to earn a living by recording their clients as they would wish to be portrayed, in moments of triumph, dressed in their robes of office or surrounded by evidence of their power and wealth.

Achieving a 'likeness'

A 'good likeness' implies that the sum of the features is instantly recognisable to anyone who has met or seen the subject. And it is generally assumed that all the greatest portrait painters were able to oblige their patrons with such a likeness. But the artist does not necessarily reveal much about the character of the subject by merely reproducing the features of the sitter. No portrait is objective for it is a record of how one person sees another — some are sympathetic, others cold and formal, others are satirical. A portrait may, in fact, tell us more about the artist and the relationship betweeen the artist and the sitter than it does about the subject.

The underlying structure

The skull provides the basic framework for

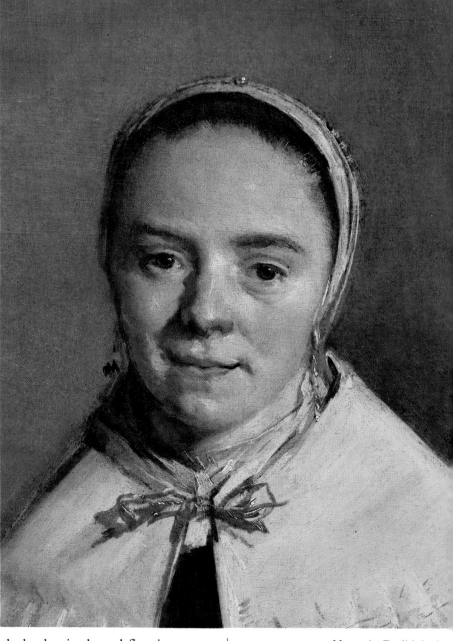

the head — its shape defines its structure and the bones provide the anchorage points for the muscles. The skull is divided into two main components — the cranium which protects the brain and the facial bones which define the features of the face. There are 28 bones in the human head and all except the jawbone are firmly attached to each other.

At birth the head forms a greater proportion of the total body length than in adults and the cranium in turn occupies a larger proportion of the volume of the head. The cranium is composed of thin curved plates which in the new born are separated by fibrous tissue at their edges. In the first years of life the bones grow and fuse together to form a rigid protective casing. The skull of an infant differs from that of an adult and much of the excess tissue around the cheeks camouflages the facial bone

Above An English Lady *by Hans Holbein (1497–1543). This was a study for a group portrait of the family of Sir Thomas More The woman is thought to be Margaret Roper, one of More's daughters. Holbein method was to make meticulous drawings from life and to use these drawings as the basis of a painting.*

structure which will become more prominent as time goes by. With old age the skin tends to lose its elasticity and sags so the bones appear to be nearer the surface. The degree to which a person's bone structure can be seen depends on factors such as sex, age and racial origin.

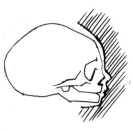

These three skull diagrams show some of the changes that occur in the face between infancy and old age. In the first (above) — showing the head of a young child — the upper part of the head is large and long in relation to the face. Notice the jaw which is hardly developed at all.

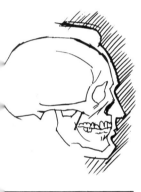

With the growth of teeth and the strengthening of the jaw-bones, the face lengthens and the forehead becomes more prominent (above) so that in the adult there is less difference in size between the face and the skull.

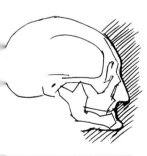

In old age, teeth are lost, the skin loses its elasticity, and muscles waste so that the features of the face tend to droop and the bones of the skull become more prominent. It is important to be aware of the shape of the underlying bone structure when drawing or painting faces of any age.

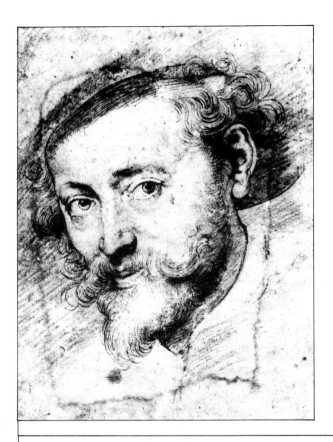

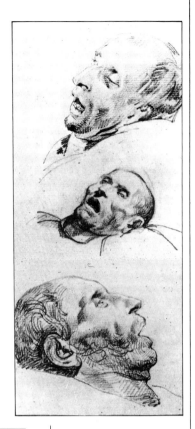

Above left Self Portrait, by Peter Paul Rubens (1577–1640). Rubens was a gifted draughtsman and a wonderful colourist. Like Rembrandt and many other artists he painted his own face several times. These paintings and drawings are exercises in capturing emotions and expressions.

Above *Théodore Géricault's studies for* The Raft of Medusa *reflect the artist's impassioned reaction to the aftermath of the shipwreck. The faces express both fear and loss.*
Left *By contrast, a modern artist has captured the innocence of youth in this sketch of a sleeping child.*

PORTRAIT OF A YOUNG GIRL

In this painting the artist is concerned with the effect of light on the model, the way it illuminates and describes the form and at the same time dissolves it into strange and abstract shapes and facets. The way in which a subject is lit can affect a painting in many ways. Light can change the mood of a painting and also influences the colours which can be perceived. Notice the way in which the finished painting dissolves into patterns of light and shade as you approach — it only really 'reads' when viewed from a considerable distance.

One of the most important and most difficult aspects of portrait painting is achieving good skin tones. The colour of skin varies enormously depending on race, age and even on the amount of sun you have been exposed to. Many experienced painters have a formula for achieving good flesh tones and you will undoubtedly evolve

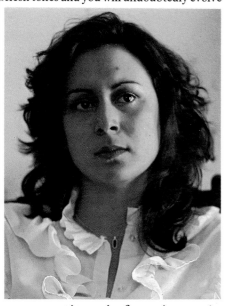

your own. A word of warning — the commercially available paints called 'flesh' are sadly misnamed. Some are actually a bright salmon pink, so don't think you have found the easy way out when you come across one in your local artist's supply shop.

The best way to paint flesh it to look carefully at the subject and paint what you see. Work cooler colours into your shadow areas and warm colours onto the highlighted areas on the cheek, forehead and nose. Apply the paint lightly and freely, working wet-into-wet as the artist has done here, or laying down patches of pre-mixed colours — a method used in some of the other paintings in this book. An overworked paint surface can 'kill' a portrait more surely than any other subject — skin must look fresh and living to be convincing.

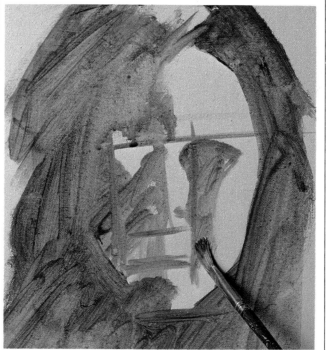

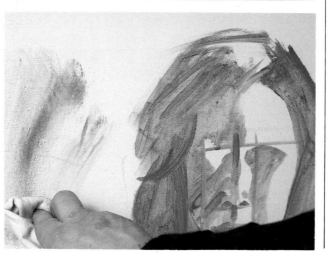

*The artist spends a considerable time considering the pose. He sits the model (**far left**) so that the light falls on her from the window on the right. Because the light source is natural the artist has to work quickly in order to get as much of the painting down on canvas as possible, before the light changes. He works on the picture over several days, returning to it at the same time of day so that the light conditions are almost constant.*

*The artist selects a fine grained prepared board (24 x 30 in). Using cobalt blue thinly diluted with turpentine he starts to draw in the main outlines of the head. Notice the way in which he marks the line of the nose and the chin, the horizontal which runs through the eyes and the left side of the nose (**left**).*

*Using the same washy paint and a no 5 flat bristle brush he starts to block in the shadow areas. At this stage he is not concerned with the details of the head. He concentrates on the broad areas of light and dark and the forms emerge very quickly (**left** and **below**).*

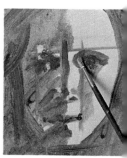

*Using a rag the artist smudges in some areas of tone to indicate the shadow behind the model (**left**). The rag can also be used to correct the drawing where necessary.*

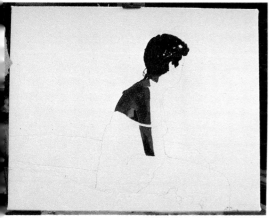

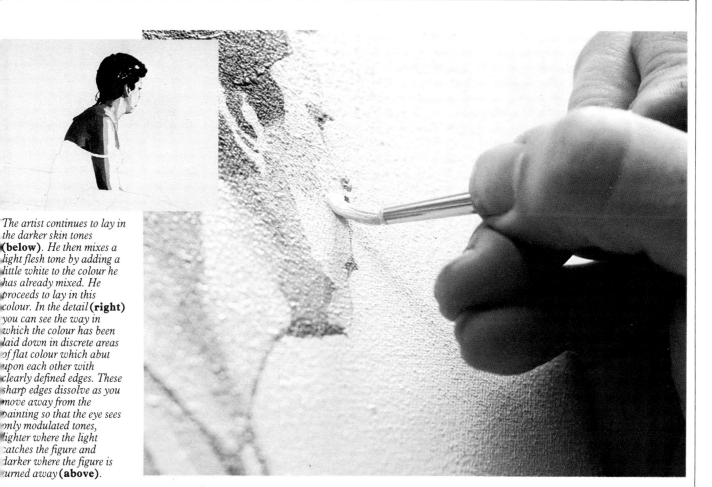

The artist continues to lay in the darker skin tones **(below)**. He then mixes a light flesh tone by adding a little white to the colour he has already mixed. He proceeds to lay in this colour. In the detail **(right)** you can see the way in which the colour has been laid down in discrete areas of flat colour which abut upon each other with clearly defined edges. These sharp edges dissolve as you move away from the painting so that the eye sees only modulated tones, lighter where the light catches the figure and darker where the figure is turned away **(above)**.

The artist is working with fairly fluid paint thinly diluted with turpentine. He uses a small, soft, synthetic fibre brush for working into the areas of fine detail. He continues to work across the whole figure, dividing the skin tones into areas of lights and darks **(left)**. His approach contrasts with the loosely worked paint and rich impastos of the previous portrait.

In the detail **(left)** he adds black and raw umber to the skin tones to obtain a dark brown for the very darkest areas. Notice the way in which the texture of the canvas shows through the thin paint layer, acting as a unifying factor throughout the painting.

Oil paint is a very flexible medium and the paint can be handled in a variety of ways, from thick impastos to thin glazes. In the previous painting the artist mixed his colours on the palette and also slurred colours together on the canvas to create a new colour. Here the artist mixes each colour on his palette, and then applies the colour, without further mixing.

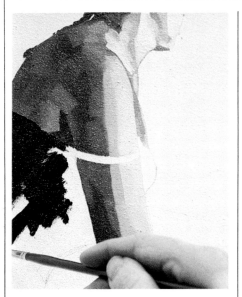

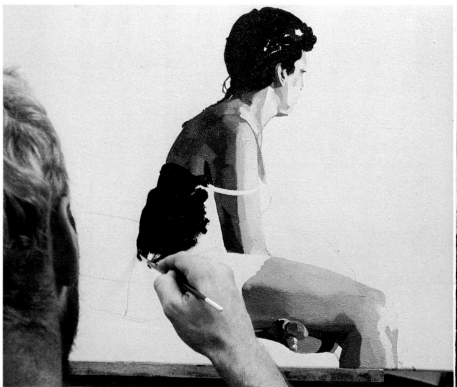

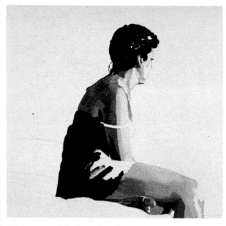

Using pure black paint, the artist starts to lay in the black underslip (**centre left** and **right**). He leaves the highlight areas white, ready to receive the lighter tone later (**above**).

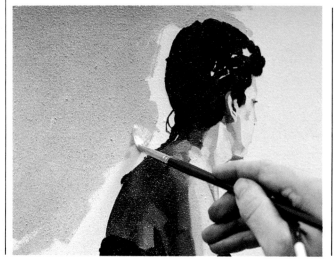

Now the artist mixes a creamy colour using white and raw umber and with this starts to lay in the background. The paint is fluid and does not hold the marks of the brush, creating areas of matt, untextured colour (**left**).

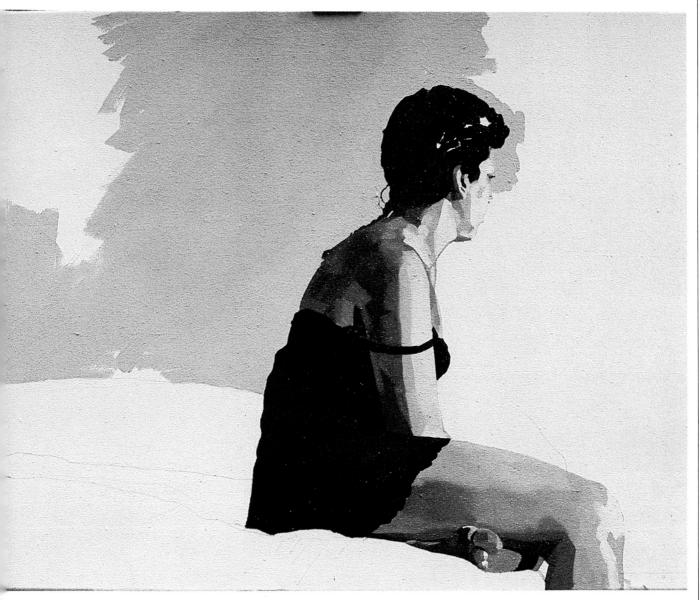

He continues to work into the background, using a small brush to create the complicated contours of the figure (**above**).

In the detail on the **left** the artist is using a mixture of cadmium red deep and raw umber to describe the shadow areas of the red coverlet. He uses several shades of one colour to establish the lights and darks — here, on the body of the model and even on her slip. He matches the pigment to the colour of the subject as closely as possible, before putting it on the canvas. Other artists take a close equivalent of the colour and lighten or darken it on the canvas. Remember that colours are modified by surrounding colours so that a colour which looked right on the palette may look wrong when it is laid on the canvas.

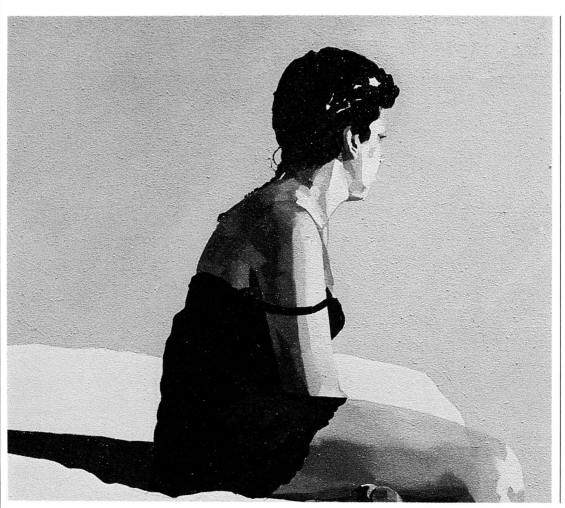

This painting illustrates the way in which subtly varied tones, applied in small, flat areas of colour, combine to create a solid, three-dimensional form on the canvas **(left)**. The limbs have a convincingly rounded quality because the skin tones change gradually from light to dark across the form, as the quantity of light reflected changes **(below left** and **right)**.

In the picture **(bottom right)** the artist uses pure cadmium red to add a final exciting touch of colour.

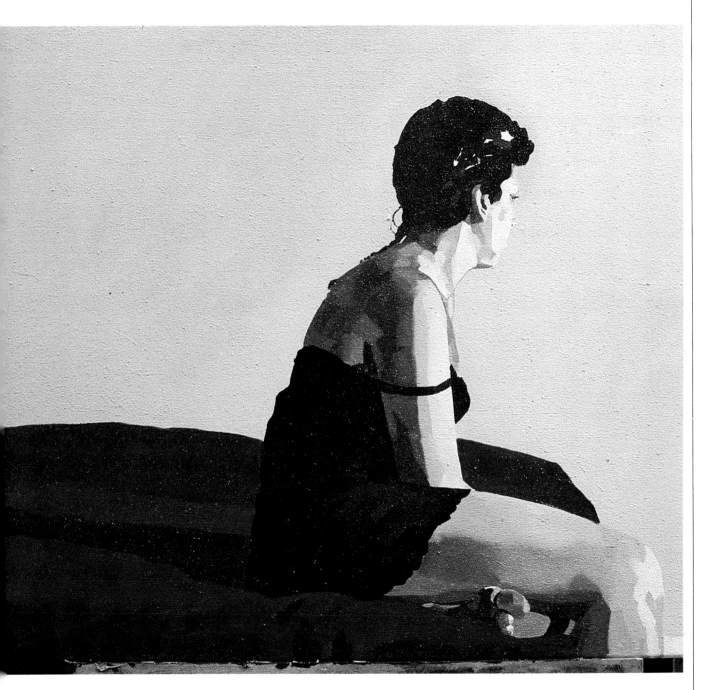

In the final picture we see the way in which the artist has let the white of the canvas stand for the highlight areas where the most direct light is striking the figure. He has worked up to the area of light, painting the darks and the mid-tones so that the highlight areas are established by a process of elimination — they are where the dark is not. He has 'felt' the shapes and volumes of the figure and has created an image which has both bulk and weight. The painting is also a pleasing abstract pattern, the areas of red and black creating interesting patterns against the relatively empty background.

A SELF-PORTRAIT

An artist is often his or her own best model — no other model will ever be so patient, so readily available or so cheap. Most of the great artists have painted self-portraits during their career. Rembrandt painted a series throughout his life and they are a wonderful record of his development as a man and as an artist.

Setting up a self-portrait is important. Make sure that you have a mirror in which you can easily see yourself without twisting or stretching. You should be able to look from the canvas to the mirror merely by shifting your gaze. Ensure that you have an adequate light source — it can be artificial or natural. The light should be sufficient to see by but it should also add interest to the painting. Make sure that you can reach all your materials easily and don't forget to

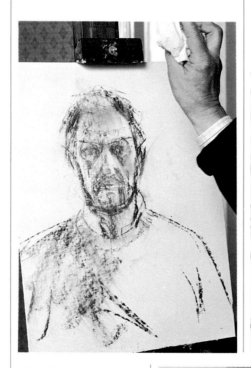

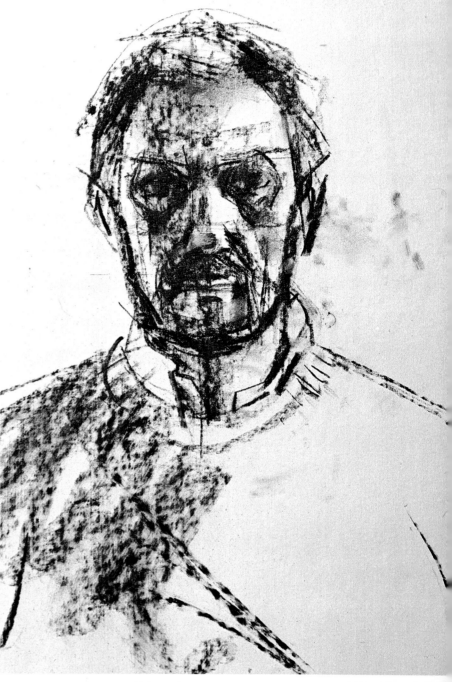

*Here the artist has used charcoal to establish the broad outlines of the subject. He has used line to set out the main structures and has used the side of the stick to lay in broad areas of tone. Charcoal is soft and dusty and the black powder will contaminate any paint you lay over it unless it is fixed. Alternatively, you can use the method shown **above** and **right** which is to brush off the surface powder by flicking it with a duster. You can re-establish the lines of the drawing at this stage by tracing over them with paint.*

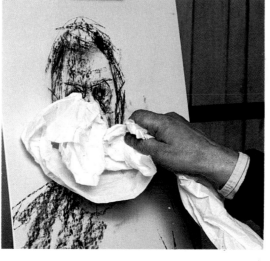

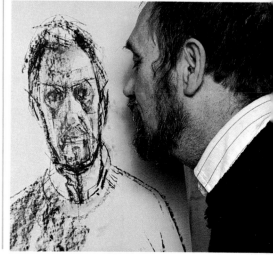

mark the position of the easel, the mirror and your feet so that when you step back or leave the painting for any period of time you will be able to resume the position and pose again.

The artist started by making a fairly detailed underdrawing using charcoal. The degree of detail in the underdrawing depends on the method of working of the artist. Some produce a very sketchy underdrawing and work up the details in paint; others, as in this case, use the drawing to work out aspects of the composition such as the distribution of the tonal areas.

The artist's approach was simple and direct. He painted what he saw, concentrating on tones and shapes but has nevertheless achieved an excellent likeness.

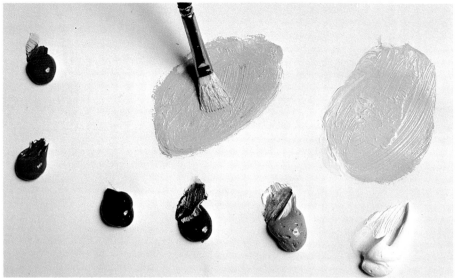

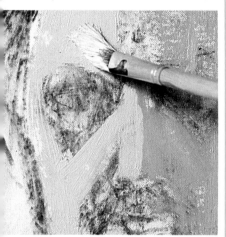

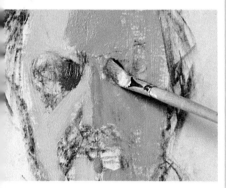

The artist starts by laying out his initial palette of cadmium red, cobalt, burnt umber, burnt sienna, yellow ochre and white **(top)**. *He will add other colours as the painting progresses. Next he mixes some flesh tints using combinations of ochre, white and burnt sienna for the warmer tints adding cobalt for the cooler tints. With quite thin paint he starts to block in the main tonal areas of the face, identifying the subtle changes by peering at his image in the mirror through half-closed eyes* **(above and right)**.

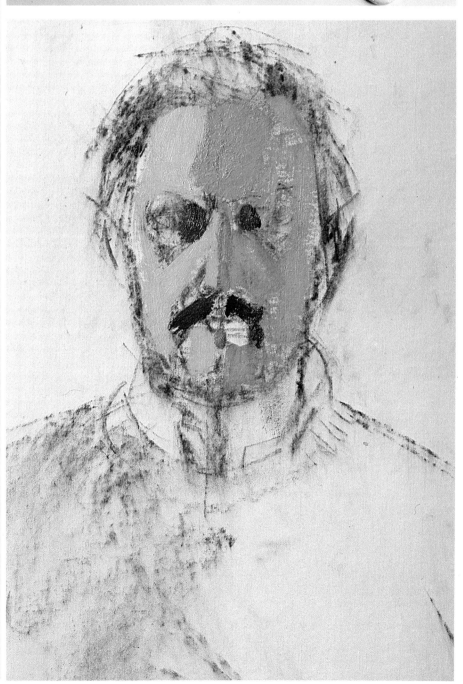

(Right) *the artist is using a small bristle brush to lay in a dark tone for the hair. He uses thin paint at this stage so that he can paint over it at a later stage if necessary. By starting with relatively thin paint the artist can build up the layers of colour gradually. If you are working* alla prima *you will create a thick impasto immediately, especially if you are working with a palette knife. The technique depends on the directness and freshness of the approach — the paint is not modified after it has been applied to the canvas. Impastos can be subtly changed if necessary by applying thin glazes.*

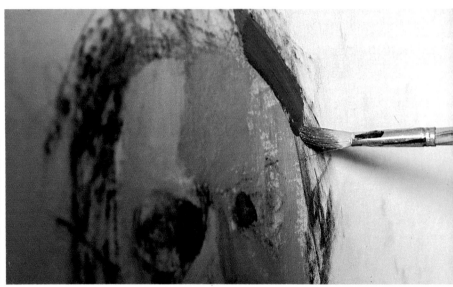

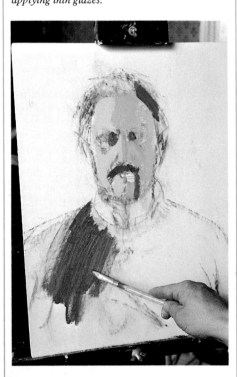

As with all painting it is important to remember to return to the subject at regular intervals. You should step back from the painting and spend time considering it carefully. Here the artist **(below)** *is using a long handled brush so that he can work at a distance from the support. In this way he can see both the painting and his image in the mirror at the same time.*

(Above) *the artist starts to block in the broad areas of colour of the clothing. He works quickly using thin, easily worked paint. This blocking-in allows the artist to assess the painting — are the main elements of the painting successfully arranged within the picture area? Is it a good composition? You may, for instance, decide that you have included too much of the background, or too little. In this case the artist was particularly concerned about the position of the head and whether he should include more of the torso. Remember that it is never too late to change an oil painting, though obviously it is easier to make changes at earlier stages.*

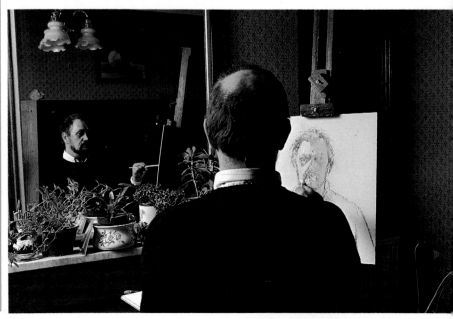

Keep checking the light — if it is from a window you may find that is has changed considerably while you have been absorbed in your work **(right)**. Try to establish the light and dark of the skin tones accurately in relation to each other. It does not matter if the painting looks untidy or if the brushstrokes are visible. These add to the liveliness of the paint surface. These textures are an important element of many paintings — an artist's brushmark can be just as characteristic as handwriting. The detail **(below)** shows how exciting a textured paint surface can be.

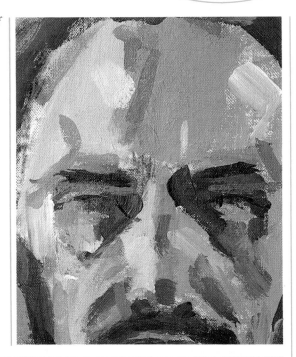

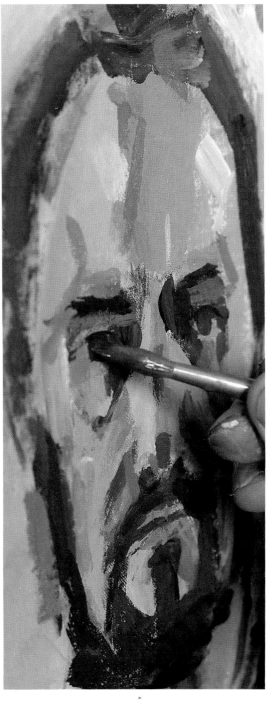

The painter starts to develop the eyes **(above)**. There is a temptation to pay too much attention to them, especially in self-portraits. This is because we concentrate on the eyes when we are talking to people and feel that they reveal the personality. In self-portraits this often results in a strange fixed gaze. The eyes should be described in no greater detail than any other part of the portrait. Here the artist has used broad, simple strokes of paint.

Having laid on the basic skin tones the artist now considers the details: the eyes, nose and mouth. Do not 'draw' these features or paint what you *know* to be there. Study your face carefully in the mirror and put down what you see, no matter how strange it may seem. Gradually the features will emerge.

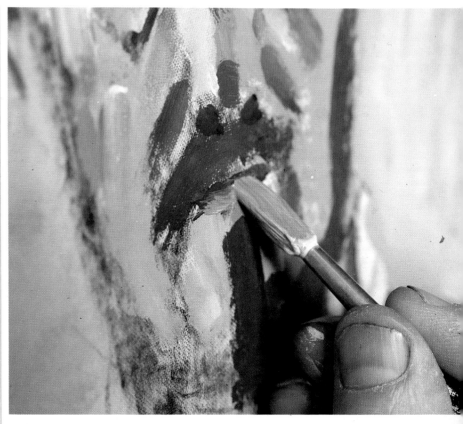

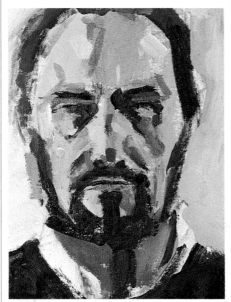

Here the artist is building up the shadows under and around the lids **(above)**. and under the nose. By reducing the subject to a series of simple planes — banishing the idea of a face from his mind and perceiving the subject as an abstract the artist will be able to be more objective and therefore more accurate. This is difficult to do when you are painting your own portrait. After all you probably study your own face in the mirror every day of your life and, quite justifiably, feel that you 'know it'.

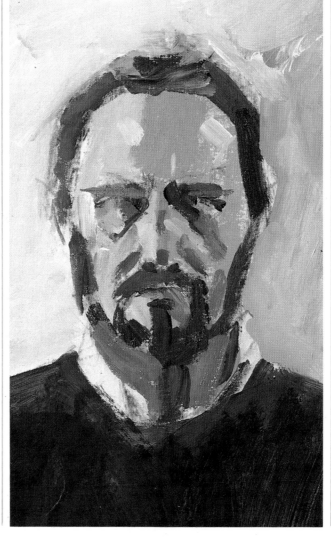

The artist has also worked on the mouth. In the picture at the **top** of the page he is laying in two broad slashes of colour to describe the lips. He uses a lighter tone for the lower lip which catches the light. On the **left** we see that he has established the dark shadow under the lower lip and **above** he has 'knocked back' the brilliant red so that it looks more natural.

The artist studies the painting carefully at this stage and then makes any adjustments which are necessary. **Right** the artist adds touches of darker tone to increase the depth of the shadows. **Below** he adds small areas of subtle tone to complete the shape of the face. **Bottom** he adds final tones to the eyes without making the colours too pronounced. The final picture is simple but convincing — the artist has not attempted to achieve a high degree of finish but has let the paint stand as fairly rough patches of colour. Seen from a distance these colours merge but the broken texture animates the paint surface.

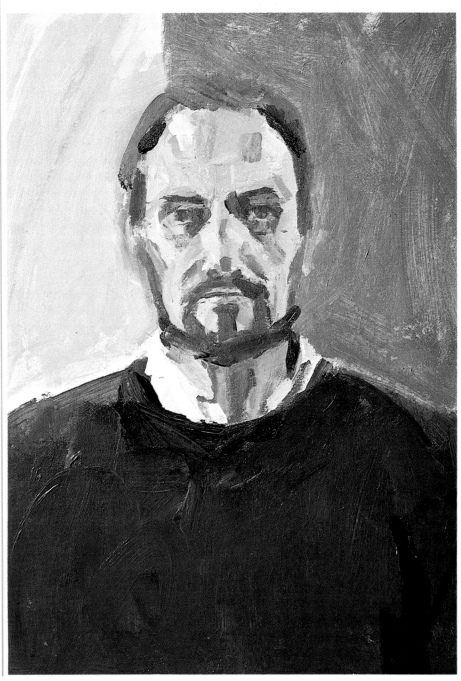

PORTRAIT OF A CHILD

Children's heads contrast strongly with the more sculptured look often found in the heads of adults and therefore deserve special study. In babies, for example, the size of the features are small in relation to the size of the head — and a baby's eyes, nose and mouth are much the same size. The neck which at the earliest stages cannot support the head, remains thin and unstable for quite some time. The way in which the neck enters the cranium is quite different from that in an adult. The cranium is large and grows only slightly after babyhood — and the eyes appear overlarge.

In older children the forehead is curved and appears large due to the small size of the face. The neck is thin, the cheeks full, the chin small and the bridge of the nose is not clearly defined.

The figure of a child is leggy with a protruding tummy, narrow shoulders, and thin arms and legs. All these factors should be reflected in your painting. Even the pose will be different from that of an adult, children tending to adopt upright, rather angular poses.

If you do ask a child to pose remember that their concentration span is short and that they will soon get tired. Allow them frequent breaks and try to make the sessions fun. You will need to make several rapid sketches and you should consider taking photographs. You can refer to these when your young model's patience has run out.

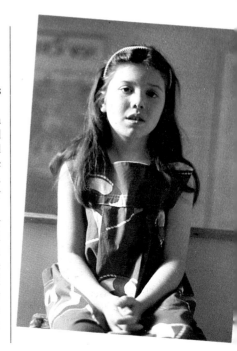

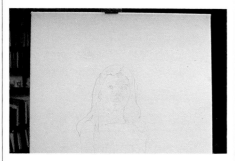

The artist poses his young model, making sure that she is as comfortable as possible (**top**). *He then selects a hard (H) pencil to make a drawing of the subject directly onto the canvas, putting in the outlines and suggesting the main areas of tone. Using thinly diluted paint the artist starts to block in the dark areas of the girl's hair* (**right**).

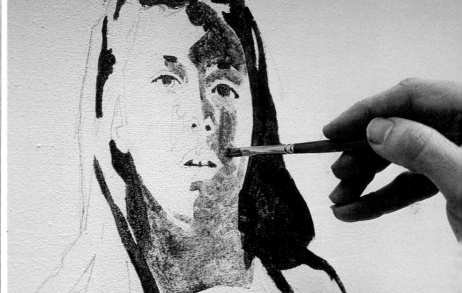

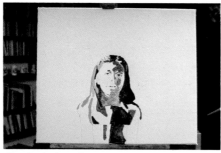

For the darkest skin tones the artist uses raw umber, burnt sienna and black (**centre** *and* **right**). *He paints the shaded areas of the dress with a mixture of black and cerulean blue, keeping the paint thin and washy* (**above**). *A mid skin tone is created from black, white and yellow ochre. A touch of cadmium red is added to the lips.*

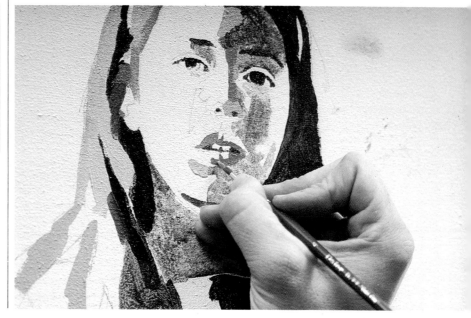

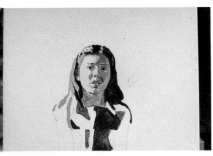

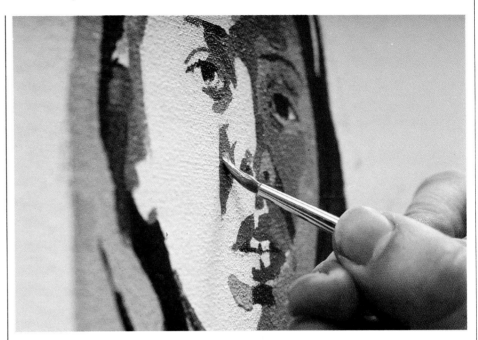

This artist mixes his colours carefully on his palette. Each area of tone is painted as a discrete patch of colour with a sharp, clean edge. The image gradually begins to emerge as these facets of colour build up like the pieces in a jigsaw. He stands back to see how the pieces are fitting together, and makes adjustments as necessary **(above** and **right).**

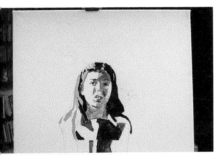

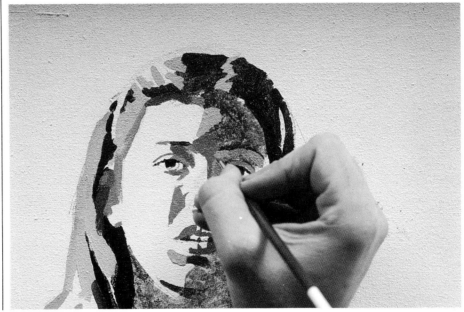

Here the artist is creating a range of subtly graduated tones from very few colours **(above** and **right).** **Below** he adds the whites of the eyes using a mixture of white, yellow ochre and black. The flesh tones begin to coalesce and the girl's features and the structure of her face begins to emerge **(far right).**.

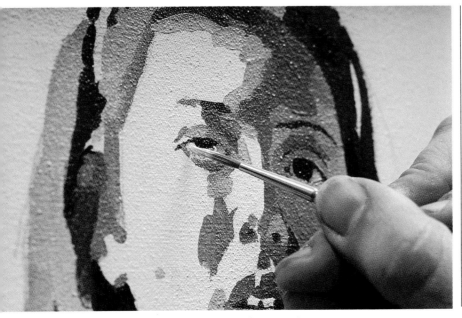

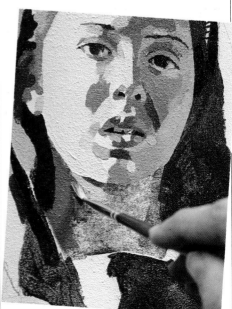

Using the skin tones which he has already mixed on his palette the artist paints in the remaining flesh areas — on the shoulders, neck and arms (**above left** and **right**). The picture below shows the contribution this makes to the picture so far.

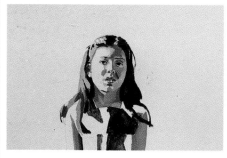

The artist uses cerulean blue, black and white to mix a light tone and a darker tone for the girl's blue frock (**right** and **centre**). He has already established the darkest areas so he uses these two new shades to block in the remaining areas (**right**).

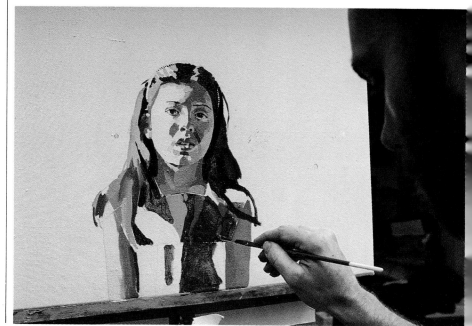

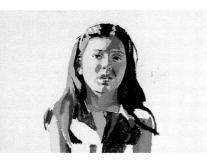

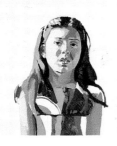

*The artist has blocked in the main areas of blue (**top** and **above**). He now concentrates on the details of the frock using a small sable brush. **Top right** he is using a mixture of cerulean blue and black, and for the trimmings (**below right**) he uses cadmium red. He continues to lay down the paint as areas of flat colour with no modulation of tone within a particular patch of colour.*

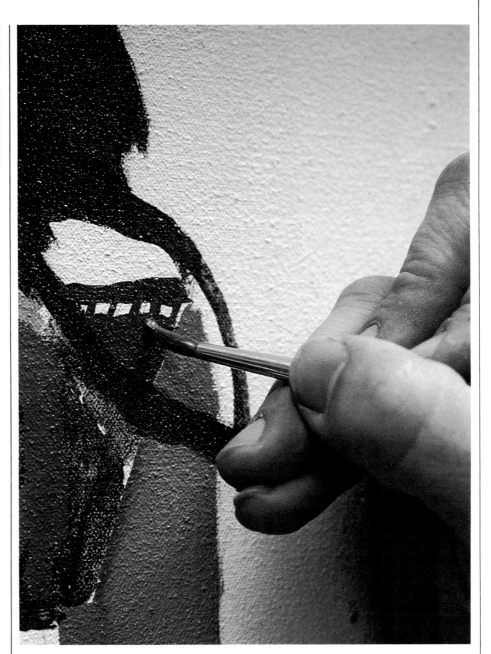

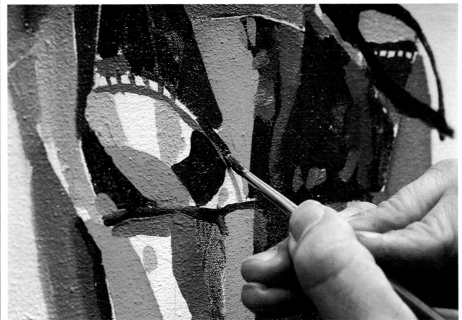

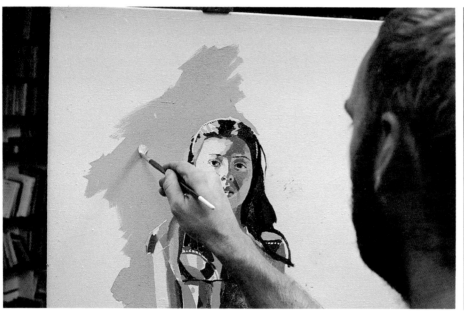

The artist mixes a large quantity of white and raw umber for the background. This was applied with broad sweeping movements using a large brush. The artist applied the paint flatly, working up to the outline of the figure, except for an area of white canvas left to stand for highlights on the hair (**above** and **left**).

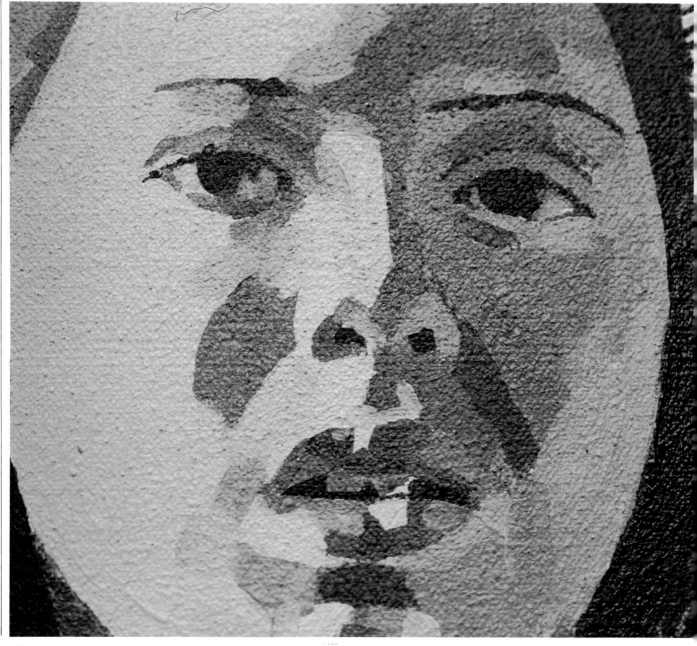

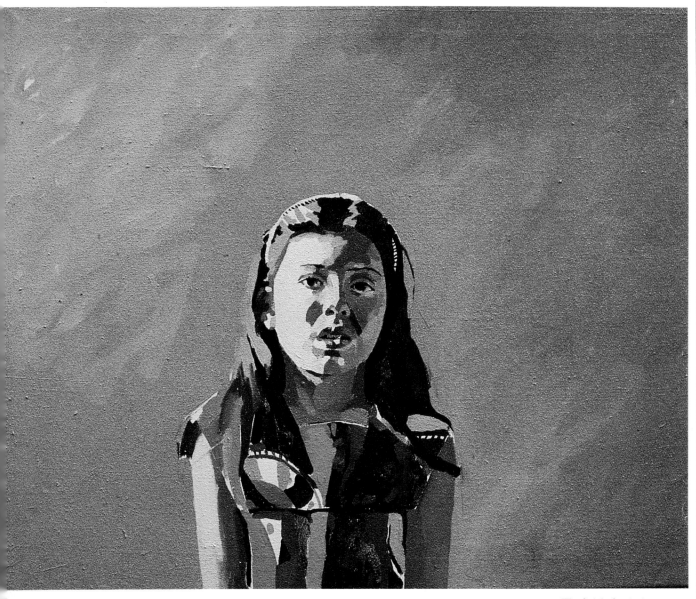

Once the background has been established the artist studies the painting yet again and makes any adjustments necessary (left).

The finished painting captures the alert and serious mood of the young model. The large surrounding empty space creates a sense of isolation, drawing attention to her youth and vulnerability. The artist's approach is realistic and he has achieved an excellent likeness, however the way in which he has broken the paint up into areas of flat colour introduces an element of abstraction which adds interest to the painting.

GIRL WITH A RED NECKLACE

The approach in this painting contrasts with that in the previous painting — the portrait of a child. There the paint was applied in discrete patches of flat colour. Here the same artist applied thin washes of paint which are built up methodically, each layer being allowed to dry before the next layer is laid over it. The artist started with an accurate and carefully considered drawing. He used only a limited range of colours, exploiting warm and cool colours to describe the form of the features. Cool colours like blues tend in general to recede whilst warm colours like red advance. The artist uses warmer colours on the forehead and the nose, and cooler colours on the turn of the cheek and neck.

The composition also provides us with an interesting contrast with the previous painting. In that case the artist chose to set the figure towards the bottom of the page surrounded by large areas of empty space. In this case, however, he has cropped in to the image so that the girl's head fills the picture area. As a result the painting is more energetic and less contemplative in mood. The painting has been carefully and thoughtfully rendered, but it has, nevertheless a fresh and lively feeling.

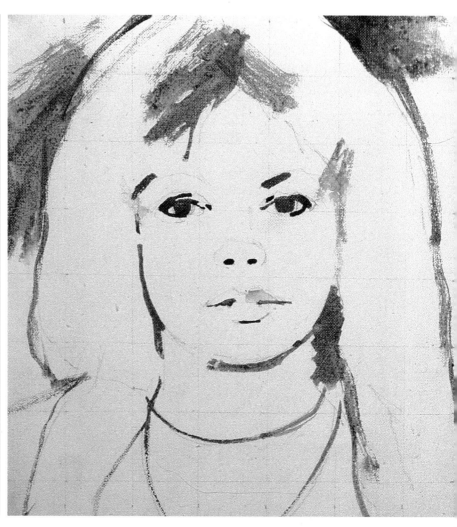

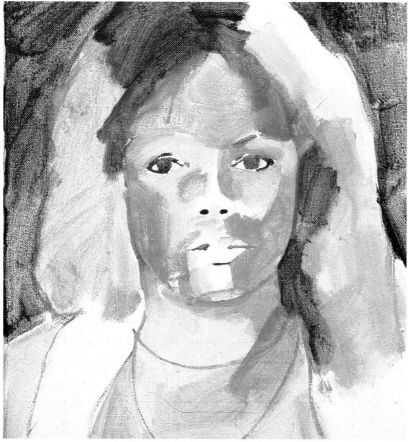

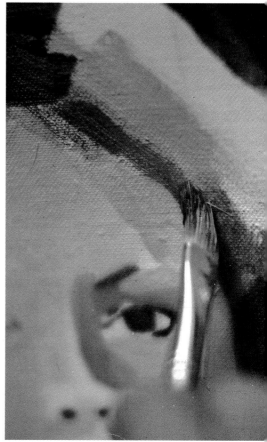

For this painting the artist worked from a sketch which he had made from life at an earlier date. He reproduced the image by drawing a faint pencil grid over the sketch. He then made a grid consisting of the same number of squares, on the canvas. He was able to copy the original sketch square by square. You can see the lines of the grid in the picture on the **facing page, (top)**. He used a burnt umber wash to block in the main outlines. Still using thinned paint he blocked in the rest of the subject: gold ochre for the hair, thinned umber for the background and sienna mixed with white for the flesh tones of the face **(bottom left, facing page)**.

In the picture at the **bottom right (facing page)** we see the artist using a flat bristle brush to paint in the darker tones of the hair. This detail shows just how thin the paint is and the way in which the texture of the canvas is revealed through the paint layer.

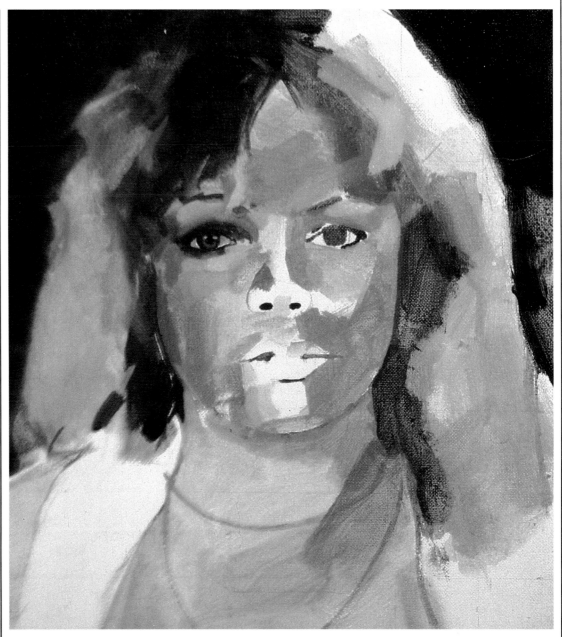

Using a deeper shade of umber, the artist darkens the background and works into the shadows on the hair and around the eyes **(top right)**. With a mixture of burnt umber and white he then redefines the facial planes, introducing some cadmium red for the warmer areas at the tip of the nose and over the cheek bones **(bottom left)**.

He then mixes a warm flesh tint from burnt sienna, red and white and works over the face, blending the paint and melding the tones. With the handle of his brush he scratches into the paint to create the texture of hair **(bottom right)**.

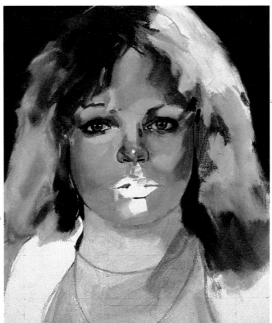

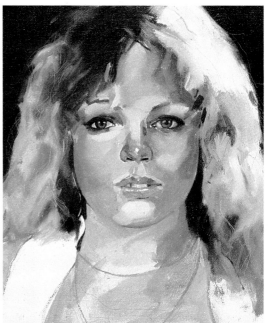

63

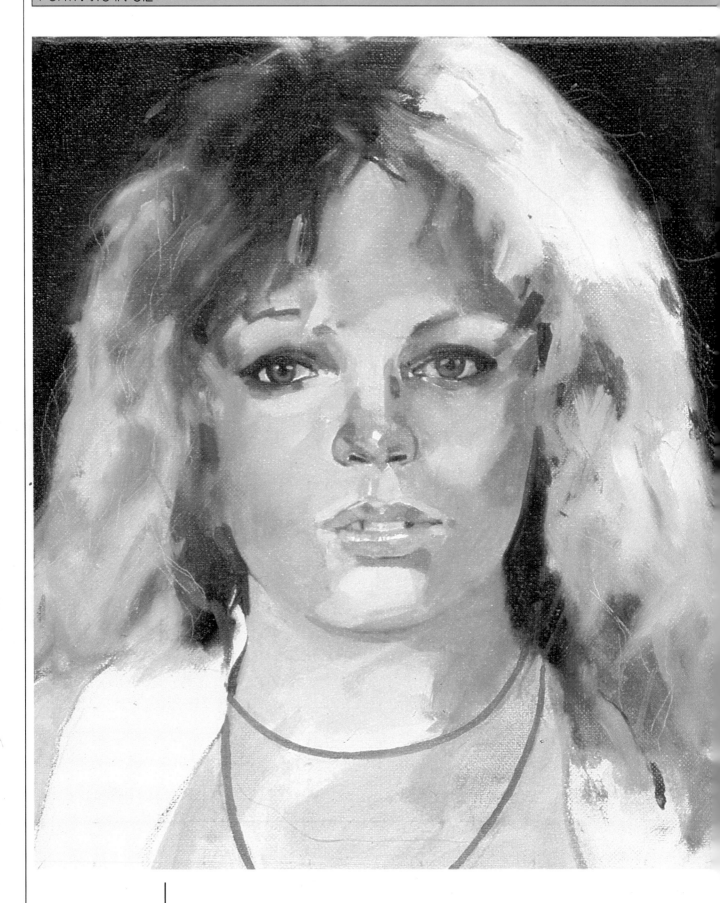

The artist completes the
picture by painting in the
necklace using a pure
cadmium red. This adds a
final touch of bright local
colour.

1594

1 1⁹